RATHFARNHAM

MAURICE CURTIS

The
History
Press
Ireland

First published 2013

The History Press Ireland
50 City Quay
Dublin 2
Ireland
www.thehistorypress.ie

British Library Cataloguing in Publication Data.
A catalogue record for this book is available from the British Library.

ISBN 978 1 84588 825 1

Typesetting and origination by The History Press

CONTENTS

ACKNOWLEDGEMENTS

Thanks to Síle Coleman of the Local Studies Collection in the County Library, Tallaght, County Dublin for all her help and encouragement with this book and kind permission to use the Our Villages material. Tony Corcoran of the Rathfarnham History Society and the parish of the Church of the Annunciation, is an absolute mine of information and anecdotes and I am particularly grateful to him for all his help and encouragement. Gregory O'Connor, of the National Archives and chairman of the Rathfarnham History Society, does Trojan work to promote an appreciation of this fascinating historic area, and for this I am very grateful. Michael Murphy of Ballyroan Catholic Church was also helpful. The South Dublin County Council offered much encouragement and help during the research and their local history resources are indispensable. Barry Rowan of Rowan's Delicatessen was a mine of information and a great raconteur on life as it was in Rathfarnham in the old days. The late Patrick Healy's *Rathfarnham Roads* was a guiding light. Nigel Buchalter of the OPW and Rathfarnham Castle and Brian Crowley of the Pearse Museum in St Enda's Park surpassed themselves. The staffs of the National Library of Ireland, Irish Architectural Archive, the Royal Society of Antiquaries, Dublin City Public Libraries (Pearse Street in particular), South County Dublin's Ballyroan and Whitechurch Libraries were of immeasurable help. As was the Royal Society of Antiquaries of Ireland and the Irish Architectural Archive. Dublin City Council's Dublin.ie Forums offers a great opportunity to enhance our appreciation for local history also and was of particular use. Beryl Gillis of the Church of Ireland introduced me to the history and beauty of her church in the village. Rathfarnham Motorbike Shop (beside the old graveyard in the village) and all the businesses in the village were kindness itself. Thanks also to Rob Goodbody for his research on Butterfield House, now the headquarters of the Irish Pharmaceutical Union (also of particular help). Sgt O'Sullivan of Rathfarnham Garda Station was most helpful on the history of the Garda presence in the area. I am grateful to the family of Dr Joseph McGough for permission to quote him. Thanks to Jack Fagan of *The Irish Times* for information on Loreto Abbey. June O'Reilly of the Business Depot was a terrific help. With gratitude I say that Ronan Colgan and Beth Amphlett of The History Press were inspiring in their confidence, patience and encouragement. Lastly, a special thanks to the people of Rathfarnham for being so available, humorous and kind.

INTRODUCTION

Rathfarnham has to be one of the most fascinating and attractive parts of South County Dublin. Over the years it has witnessed some of the pivotal events in Irish history and has been home to some of the most important people in Irish social, religious, political and economic history, people who have left us a lasting legacy in the areas of culture, sport, music, art and literature, and much else. W.B. Yeats, James Joyce, Abraham Stoker, George Bernard Shaw, J.M. Synge, Patrick and Willie Pearse, Evie Hone, Robert Emmet, Anne Devlin and Sarah Curran, Sean Keating, Mother Teresa of Calcutta, Annie M.P. Smithson, and Padraig Harrington, all have strong links with Rathfarnham.

Bulmer Hobson (1883–1969), revolutionary and writer. He lived at Whitechurch Road, Rathfarnham. (Courtesy of Historic Pics.Inc.)

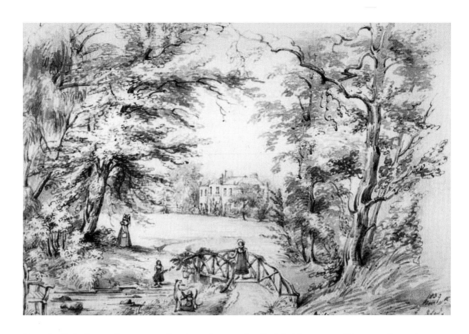

Sketch of Marlay Park Demense by Anne La Touche, 1837. (Courtesy of Historic Prints/ Dublin Parks/OPW)

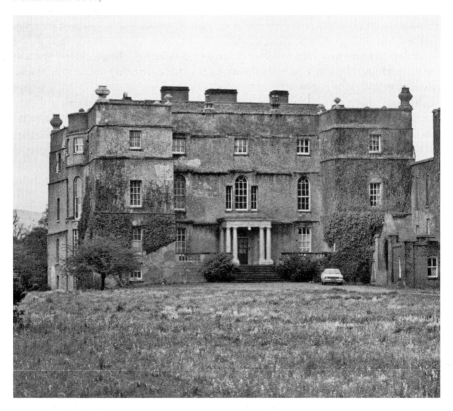

Rathfarnham Castle, 1987. (Courtesy of Patrick Healy/South Dublin Libraries/OPW)

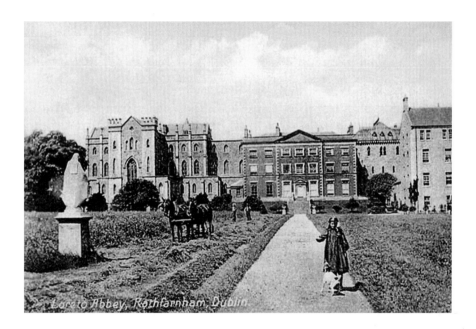

Early twentieth-century postcard of Loreto Abbey, Rathfarnham. (Courtesy of the Loreto Sisters)

Standing outside Marlay House in Marlay Park, one is overwhelmed with the beauty of the surrounding landscape. The Dublin Mountains backdrop creates a stage-like setting for the house and the surrounding park. Moreover, there are at least six parks in the wider Rathfarnham area with rivers, such as the Dodder, Poddle, Dargle, Owendoher and the Whitechurch Stream, cascading through them and enhancing the natural beauty, as well as providing recreational opportunities.

Likewise one is enthralled with the village and castle. From a slight distance one appreciates the uniqueness of Rathfarnham, with its castle and the church steeple and winding village street, built initially on a hilltop and, over the centuries, extending in every direction.

Today Rathfarnham is located to the south of Terenure, and to the east of Templeogue, in the postal districts of Dublin 14 and Dublin 16. It is within the administrative area of Dun Laoghaire-Rathdown and South Dublin County Council. The area of Rathfarnham includes Whitechurch, Ballyboden and Ballyroan. While Rathfarnham has been a desirable place to live for at least 200 years, there has been remarkable population growth in the area since the 1920s, and within the past fifty years of so building gathered further apace. The growth of population in the Rathfarnham area has resulted in the development of new schools, churches and community facilities.

A WEALTH OF TREASURES

Rathfarnham is home to several notable historic buildings and structures, including Rathfarnham Castle and Loreto Abbey, the Bottle Tower, Ely's Arch, Beaufort House, Berwick House, Marlay House, the Pearse Museum, Ashfield House, the Church of Ireland church on Main Street and the Catholic church at

the junction of Willbrook Road and Grange Road at the opposite end of the village. The area also boast six parks – Rathfarnham Castle Park, Marlay Park, Dodder Park, St Enda's Park, Bushy Park and Loreto (Nutgrove) Park – and several popular pubs, including The Eden, Revels, the Old Orchard, the Blue Haven, Taylor's Three Rock, and the landmark Yellow House.

Historical sites in the Rathfarnham townlands include: Kilmashogue, Mount Venus, Tibradden and Taylors Grange. And not forgetting the infamous Hell Fire Club atop Montpelier Hill via Scholarstown Road and Stocking Lane.

Rathfarnham is also home to the 13th Dublin and the 14th Dublin Scout troops, the Rathfarnham Girl Guides, the Ballinteer St John's GAA Club and Ballyboden St Enda's GAA Club (from which some of Dublin's best footballers and hurlers come!), the Three Rock Rovers Hockey Club, the Grange Golf Club, the Castle Golf Club, the Rathfarnham Golf Club (on Stocking Lane), Stackstown Golf Club and the Edmondstown Golf Club. There are also at least five soccer clubs and also boxing and athletics clubs. And for those looking for final resting places, the cemeteries of Whitechurch Church, the Moravian on Whitechurch Road and Kilmashogue are worth visiting. Rathfarnham is also blessed with two excellent South County Dublin public libraries – at Ballyroan and Taylor's Lane (an original Carnegie Library). A very active Rathfarnham Lions Club, the Tidy Districts Committee, the Rathfarnham Credit Union, the Rathfarnham History Society, the various Parish Councils and Committees, and other such successful initiatives, all point to much volunteering and proactivity on a grand scale in Rathfarnham.

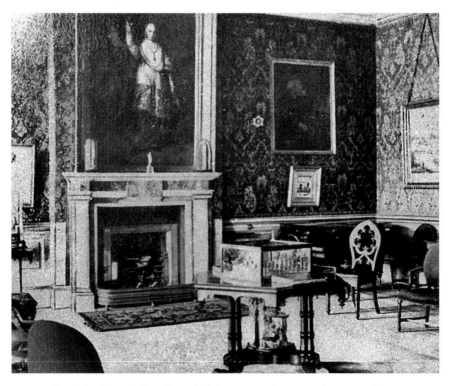

Interior of Rathfarnham Castle at the end of the nineteenth century. (Courtesy of Patrick Healy/South Dublin Libraries/OPW)

A group of golfers at Rathfarnham Golf Club in the early 1930s. (Courtesy of *Irish Independent*/National Library of Ireland)

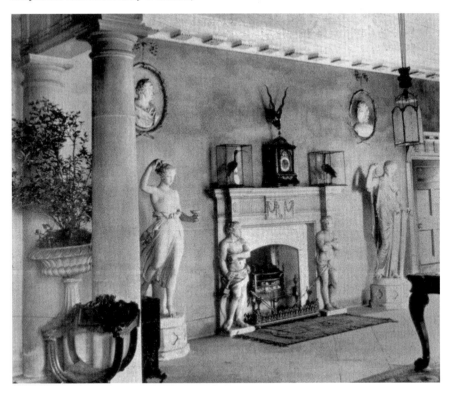

The Hall of Rathfarnham Castle. (Image taken from the book *History of the County of Dublin*, Part II, by F. Elrington Ball (1903)/OPW)

1

A BRIEF
HISTORY

EARLY HISTORY OF RATHFARNHAM

The name Rathfarnham suggests an early habitation as it comes from the Irish *Ráth Fearnáin*. A *ráth* was an Early Christian period ring fort built on an elevated level to protect farms or dwellings. Some sources suggest that *Ráth Fearnáin* means the fort

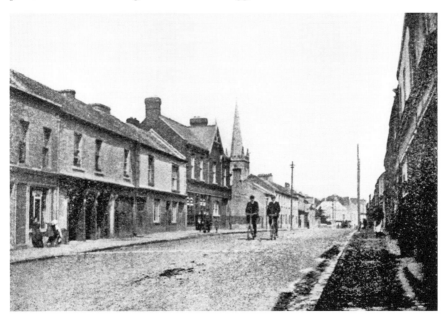

Rathfarnham village, 1906. (Image taken from the book *The Neighbourhood of Dublin* by Weston St John Joyce (1921))

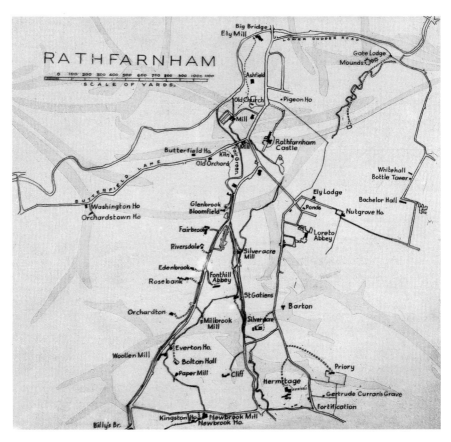

Early nineteenth-century map of Rathfarnham showing principal dwellings and mills.
(Courtesy of Patrick Healy/South Dublin Libraries)

of the alders, a species that can be found growing along the Dodder. A more common interpretation, however, is that it means the fort of Fearnán. It is not known who Fearnán was and there are no traces of where he lived or of prehistoric burial places or early churches in the area.

The earliest written reference to Rathfarnham that survives dates to the Anglo-Norman invasion, when, in 1199, the lands were granted to Milo le Bret after the O'Byrne and the O'Toole Clans had been evicted and forced to flee to Wicklow. This was an important change and for centuries afterwards the lands were under constant threat from the evicted clans. It led to the building of a line of defence and fortifications, protecting an area, which included Dublin, from the attackers. It was known as the Pale.

THE MOTTE AND BAILEY

Le Bret adapted an existing ridge to build a motte and bailey fort at what is now the start of the Braemor Road. Some remains of this defensive structure can still be seen on Lower Dodder Road/Dodder Park Road. It was built on a narrow ridge about 50ft high which is formed between the river Dodder and the stream

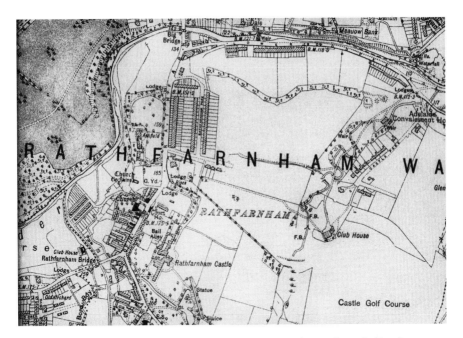

Early twentieth-century map of Rathfarnham. (Courtesy of Patrick Healy/South Dublin Libraries)

which flows through what is now Rathfarnham Castle. The early fortification was made of wood or stone, set upon a raised mound of earth called a 'motte'. The 'bailey' was an enclosed courtyard protected by a surrounding ditch. This type of defensive earthwork was used as a temporary measure until such time as more substantial stone castles could be built and in due course the fort was superseded by Rathfarnham Castle. Travelling west from Rathfarnham Bridge along Dodder View Road you can see more of the defensive and sloping structure on which the castle and village developed.

THE CLAN O'TOOLE

Le Bret subsequently leased the lands to the Harolds, who were tenants until the fifteenth century when the lands were sold to the Eustace family.

In the following centuries Rathfarnham was protected by the presence of the Royal Forest of Glencree on its southside but when this deer park was overrun by the Clan O'Toole of Wicklow in the fourteenth century, Rathfarnham became more exposed to attacks.

The current castle was constructed by Adam Loftus, Archbishop and Lord Chancellor of Dublin. He was granted the lands of Rathfarnham in 1583, by Royal Decree, and within two years had built the castle which stands today. Rathfarnham Castle is an example of a type of structure known as a fortified house.

It was highly prized as a luxury residence. More importantly, it served as a manorial centre to the surrounding estate and led to the development of the village, in part to serve the castle and the numerous villas that began to appear in the area.

Industrial activity in Rathfarnham was stepped up in the seventeenth century and in the early eighteenth century a number of gentlemen's residences were erected in the vicinity such as Old Orchard, Butterfield House, Washington Lodge, The Hermitage, Rathfarnham House, Bloomfield, Fairbrook, Glenbrook, Silveracre, Ashfield and Priory. Some of these are still standing and in use, although most have been subsumed into housing developments.

As part of the great industrial drive, mills were built which harnessed the water power of the Owendoher and other tributaries of the River Dodder, including the Whitechurch Stream. Initially most of the mills produced paper. During the early part of the nineteenth century a number of these mills changed over to the manufacture of woollen and cotton goods and later still many were converted into flour mills. However, when steam power took over from water power, many of the old mill buildings fell into disrepair, and in most cases were not replaced.

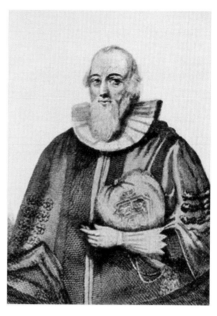

Archbishop Adam Loftus, who was granted the confiscated lands of Rathfarnham in 1583. He subsequently built Rathfarnham Castle. (Courtesy of Patrick Comerford/ South Dublin County Library/OPW)

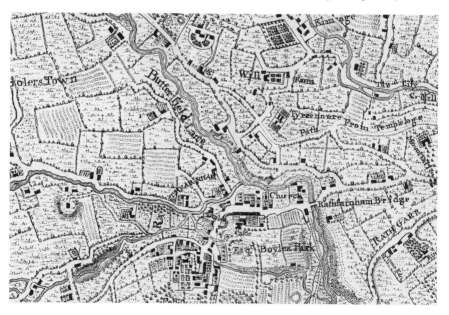

Portion of the parish of Rathfarnham, comprised of sheets XII.6 and XII.7. Surveyed in 1864 by Captain Martin R.E. and zincographed in 1865 under the direction of Captain Wilkinson R.E. at the Ordnance Survey Office, Phoenix Park. (Courtesy of OSO/ South Dublin Libraries)

2

THE
CASTLE

A CHEQUERED HISTORY: RATHFARNHAM CASTLE

The original Rathfarnham Castle, built hundreds of years before the present one, was one of a chain of castles built to protect Dublin from attack by Irish clans based in Wicklow. The discovery of secret tunnels beneath the foundations created great excitement in 1987. Designed to give the family and soldiers a means of escape in the event of an attack, they have since been closed off. One tunnel lead from the castle to an exit at the present Castle Golf Club and another lead to the Protestant church in the village.

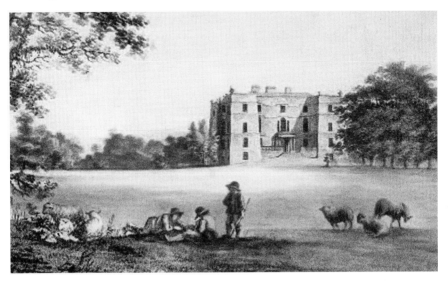

Painting of Rathfarnham Castle by George Holmes, 1794. (Courtesy of Historical Portraits Gallery Inc./Loreto Sisters)

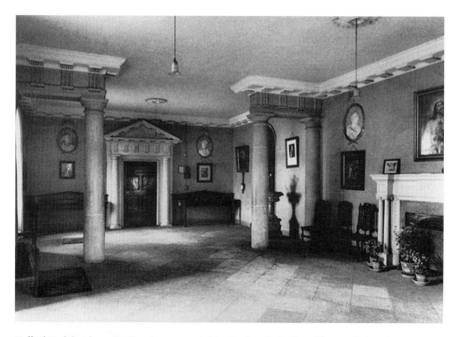

Hall of Rathfarnham Castle when occupied by the Jesuits in the mid-twentieth century. (Courtesy of Dublin.ie Forums/Damntheweather)

It is important to bear in mind that Rathfarnham Castle and the nearby village were not always separated by a wide road, as is the case now. This 'Rathfarnham by-pass' was constructed in the late twentieth century to overcome traffic congestion in the village. Before that, the castle and the village were inextricably linked and the village grew and developed mainly because of the castle.

During the Middle Ages, the castle and much of the land around Rathfarnham belonged to the Eustace family of Baltinglass, County Wicklow. However, their property was confiscated for their part in the Second Desmond Rebellion of 1579–83. The castle and its lands were then granted to the Loftus family in 1583.

THE LOFTUS CONNECTION

The present castle dates from Elizabethan times and, with its four flanker towers, is an excellent example of the fortified house in Ireland. It was built primarily to defend the Pale, but was remodelled from a defensive stronghold into a stately home and became a comfortable country residence for an ambitious Yorkshire clergyman, Adam Loftus. Loftus came to Ireland as chaplain to the Lord Deputy and quickly rose to become Dean of St Patrick's Cathedral, Archbishop (Protestant) of Dublin in 1567, Lord Chancellor of Ireland in 1581, and was closely involved in the establishment of Trinity College Dublin in 1592. With his wife, Jane, he had twenty children. He died in 1605 and the castle remained in the family for many years until 1723.

The rebuilt castle consisted of a square building, four storeys high, with a projecting tower at each corner, the walls of which were an average of 1.5m thick. On the ground level are two vaulted apartments divided by a wall nearly 3m thick

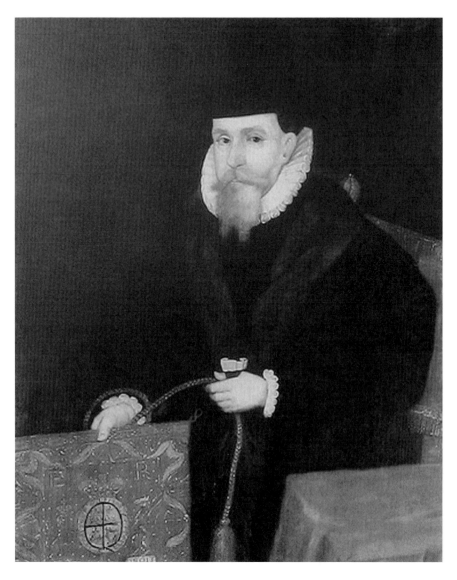

Archbishop Adam Loftus (1533–1605), Archbishop of Armagh and Dublin. He built Rathfarnham Castle. (Courtesy of South Dublin Libraries/OPW)

which rises to the full height of the castle. Level with the entrance hall were the library and reception rooms and above this the former ballroom.

CROMWELL AND SPEAKER CONNOLLY

The archbishop's new castle was not long built when, in 1600, it had to withstand an attack by the Wicklow clans and again in 1641 it was able to hold out against the Irish Confederate army when the surrounding country was overrun.

In the 1640s, the Loftus family was at the centre of the Irish Confederate Wars arising out of the Irish Rebellion of 1641. In 1649, the castle was seized by the Earl of Ormonde's Catholic and Royalist forces before the Battle of Rathmines. A few days before the battle, the castle, which was garrisoned by the Parliamentary forces, was stormed and taken by the Royalists but they probably evacuated it again when Ormonde withdrew with his army to Kilkenny. It was restored to the family by the notorious Oliver Cromwell's English Parliamentarians after their victory in that

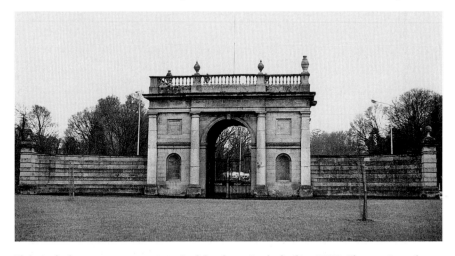

Ely's Arch: former entrance gate to Rathfarnham Castle, built *c.* 1770. The erection of this gateway is attributed to Henry Loftus, Earl of Ely. (Courtesy of Patrick Healy/South Dublin Libraries)

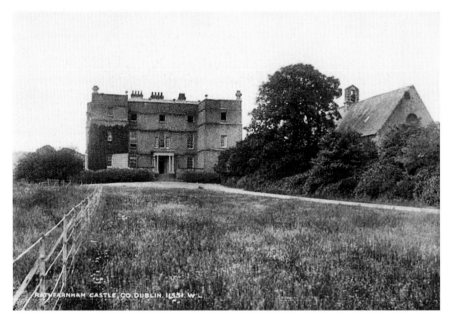

Rathfarnham Castle at end of the nineteenth century. (Courtesy of National Library of Ireland)

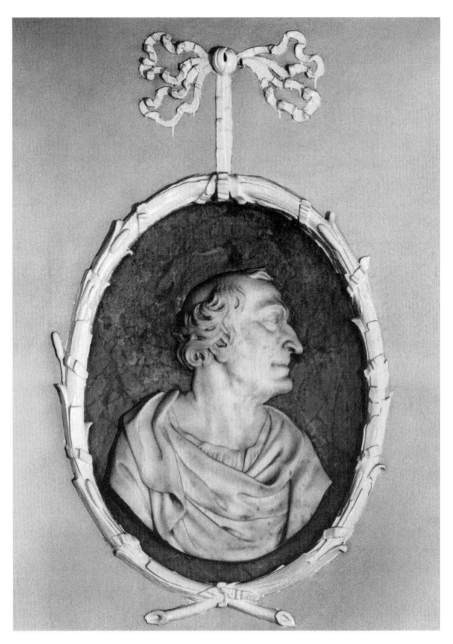

Plasterwork and image on the interior wall of Rathfarnham Castle, 1975. (Courtesy of South Dublin Libraries/OPW/IAI)

battle. Reputedly, Cromwell stayed in Rathfarnham Castle on his way south from Dublin to the Siege of Wexford.

A descendent of Adam Loftus, also known as Adam Loftus, was killed during the Siege of Limerick of 1691.

In 1723, the then owner, the profligate Duke of Wharton, who had inherited the property through his mother, Lucy Loftus (a relation of Adam), had to sell the

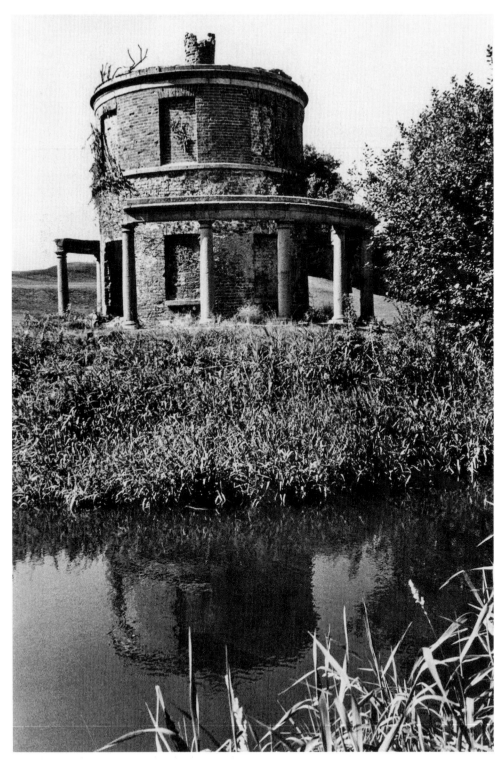

Temple, Rathfarnham Castle, 1976. (Courtesy of South Dublin County Libraries/OPW)

Temple, in grounds of Rathfarnham Castle, 1976. (Courtesy of South Dublin County Libraries/OPW)

estate to defray his enormous debts. William Connolly (1662–1729) Speaker of the Irish House of Commons, bought the property but never resided there, presumably preferring his primary residence of Castletown. He was a member of the Privy Council and ten times a Lord Justice of Ireland between 1716 and 1729. The lands of the castle at this time extended over the Dublin Mountains, including Montpelier Hill where Connolly built a hunting lodge, known today as The Hell Fire Club.

In 1767 the Loftus family returned to the castle in the person of the youthful Nicholas Hume-Loftus, 2nd Earl of Ely. In the late eighteenth century, the house was remodelled on a splendid scale by some of the finest architects of the day, including Sir William Chambers and James 'Athenian' Stuart. They created magnificent rooms with ornate plasterwork, including the beautiful gilt room and extravagant four seasons room with its Rococo ceiling. This highest quality neo-Classical decoration and Rococo stuccowork still survives. By the end of the eighteenth century, the castle was again renowned for the luxury of its apartments and its collections of furniture and works of art.

EARTHQUAKES

The twentieth century saw great changes to the castle. Houses and a golf course were built on some of the lands adjoing the castle. In 1913, the Jesuits bought the property and the remaining land. One of the Jesuits, Father O'Leary, famously constructed a seismograph at Rathfarnham Castle. The machine could detect earth tremors and earthquakes from across the world and, for a time, Rathfarnham became a source of earthquake information for the national media.

The Jesuits conducted short retreats for Catholic laymen for decades which were hugely popular in the new Ireland after Independence.

In 1985, the Jesuits sold the castle to Delaware Properties as they no longer needed it as a seminary. The sale caused great concern for local residents who feared that it might be demolished. After immense public pressure to save the building, the State purchased the castle in 1987. Today, many of the rooms have been restored to their eighteenth-century grandeur.

SKELETONS AND TOYS

The skeletal remains of a young woman were discovered in one of the hollow walls on the middle floor in 1880. It is believed that the remains had been there for over 130 years. Folklore tells us that a young fair maiden was locked into a secret compartment during one of the famous balls at the castle. Two suitors were arguing over her love and they decided to sort out their differences by way of a duel. The successor would then rescue the fair maiden from the wall. But, as it happened, both died – one from drowning and the other from his wounds. The whole affair was conducted in secret so the beautiful maiden was left there entombed in the wall, where she died.

Today the Berkeley Costumes and Toy Collection is housed at Rathfarnham Castle. Fashion and playthings offer a fascinating insight into social history. Like vernacular architecture, furniture and furnishings, clothes and toys are the physical evidence of lives lived and those lives have something to tell us. The collection is an exquisite assortment of eighteenth- and nineteenth-century toys, dolls and costumes. It began

Drawing Room, Rathfarnham Castle. (Image taken from the book *History of the County of Dublin*, Part II, by F. Elrington Ball (1903)/OPW)

as a private passion in County Wexford over twenty years ago by Irish artist and collector Countess Ann Griffin Bernstorff. The collection was gathered together over many decades from her own family trunks and from auctions and donations. Displayed in the elegant rooms of Rathfarnham Castle and covering a period of some eighty years from 1740 to 1820, the exhibits range from rare and delicate artefacts to simple and robust playthings and everyday garments of the past, many of which were once owned by Irish families.

THE PIGEON HOUSE

In the twentieth century the lands of the castle and other country houses were divided and sold, making way for large-scale modern housing developments. This included

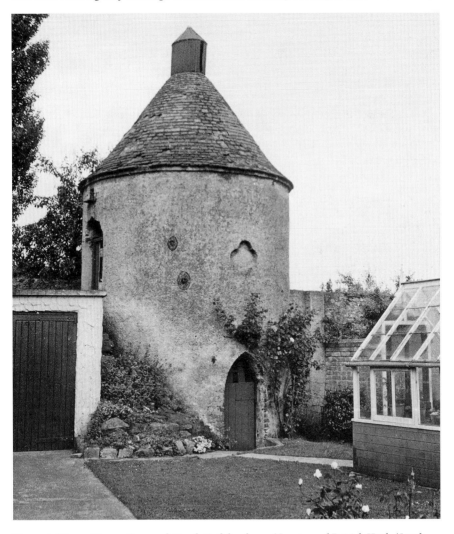

Dovecote/Pigeon House, Crannagh Road, Rathfarnham. (Courtesy of Patrick Healy/South Dublin Libraries)

the Edwardian terrace on Rathfarnham Road built in 1918, the large estates of Rathfarnham Park constructed in the 1930s and Ballytore Road, Crannagh Road and Brookvale Downs built in the 1960s.

In the garden of a house formerly named Tower Court in Crannagh Road is an ancient circular pigeon house, a relic of Lord Ely's occupation of Rathfarnham Castle. The entrance to this curious structure is by a low door and the inside is lined from floor to roof with holes for the pigeons. A floor of more recent date has been inserted half way up, so as to make two rooms, and a second door broken through the wall at that level.

4

THE VILLAGE –
GATEWAY TO THE HILLS

For many years Rathfarnham was regarded as being the 'Gateway to the Dublin Mountains' or 'Gateway to the Hills', nestling as it does at the foothills of those mountains which create a glorious natural backdrop. It has also recently been designated an 'Architectural Conservation Area'. However, in 1583 the village of Rathfarnham, which largely developed as an estate village to serve the castle, was described as a 'waste village'.

In 1618 it was granted a patent to hold fairs. A cattle fair was held annually on 29 June with one for horses and sheep on 29 July. Before that Rathfarnham's fairs

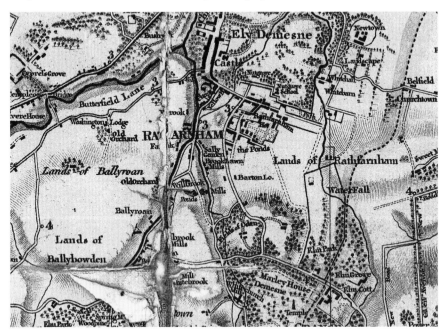

Portion of John Taylor's map of Dublin, showing Rathfarnham and surrounding area.
(Courtesy of National Archives)

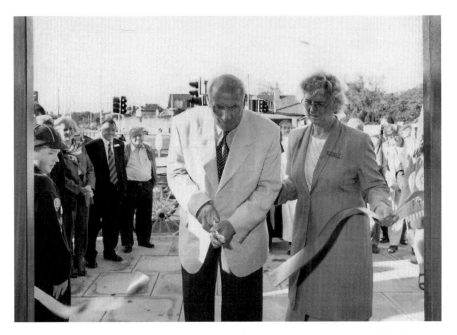

The opening of the Rathfarnham and District Credit Union on Main Street, Rathfarnham. Pictured are Marie Kelly (Chairman of the Board, Rathfarnham and District Credit Union) and Dan O'Carroll (founder member) at the ribbon-cutting ceremony. (Courtesy of South Dublin Libraries)

had been held in Butterfield Lane on 15 May, 10 July and 7 October. The fair green was beside the bridge and stretched along the west bank of the Owendoher River but the business often overflowed along Main Street and into every lane and alley.

During the eighteenth and nineteenth century paper and corn mills were established on the Owendoher and Dodder Rivers along with a woollen factory. The proximity of the village to Dublin made it a popular location for residential development and numerous small villas and country houses were built in the vicinity.

In the later part of the nineteenth century, with the introduction of trams, Rathfarnham became a suburb of Dublin with residents commuting to the city for work. Terraces of houses were built to accommodate suburban dwellers and local workers.

LANDMARK STEEPLE AND MAIN STREET

At the end of the Main Street is Rathfarnham Graveyard which contains the ruins of a church dedicated to Sts Peter and Paul. This was a medieval church and, after the Reformation of the sixteenth century, was used for Protestant worship until 1795, when it was found to be too small for the congregation and a new church was erected nearby. This fine church is still used by the Church of Ireland community. The prominent steeple is a local landmark that may be seen from far and wide. It is well worth a visit to see the beautiful stained-glass windows, the pews and the wall plaques, which include one to Abraham Stoker (1799–1876), a senior civil servant and father of Bram Stoker of *Dracula* fame.

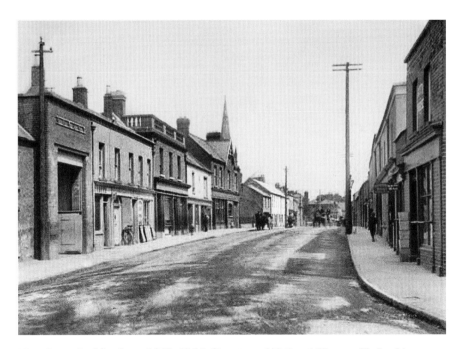

Main Street, Rathfarnham, 1880–1900. (Courtesy of National Library of Ireland/
HX Historical Society)

THE OLD GRAVEYARD – FOR FAITH AND FATHERLAND

The old graveyard is behind a castellated wall and iron gates entrance. The end
walls of the original old church still stand in the grounds, the west gable containing
a bell turret and the east pierced by a chancel arch, the chancel itself having
disappeared. The north wall is gone and all that remains of the south wall is an
arched opening.

The earliest legible headstone is that of William Phillips who died in 1689. Near
the entrance to the burial ground is the grave of Captain James Kelly, an old Fenian
who was associated with the Fenian Rising of 1867. He was organiser for the
Rathfarnham district and was known in the area as The Knight of Glendoo. On one
occasion when he was on the run he was hiding in the cellar of his business premises
in Wicklow Street when police raided it. An employee named James Fitzpatrick who
strongly resembled Captain Kelly in appearance was arrested in error and was tried
and sentenced to six months' imprisonment, which he served without betraying
his identity. Captain Kelly died on 8 March 1915 aged 70, 'a patriot'. Interred in the
same plot is Letitia Kelly, 'killed by shock rebellion', according to the inscription,
on 8 May 1916, aged 78. The words 'Faith and Fatherland' are inscribed on
the headstone.

The graveyard continued in use until it was closed in 1889 except for those
families who had continuing burial rights. The last internment was in 1968 of Mary
Margaret Shaw of nearby Bushy Park House. As well as the Shaws, other notable
families with headstones are the Yelvertons of Fortfield House and the Griersons of
Rathfarnham House. William Magee, Protestant Archbishop of Dublin, is interred
here. Bram Stoker's nurse, Ellen Crane, was laid to rest here also.

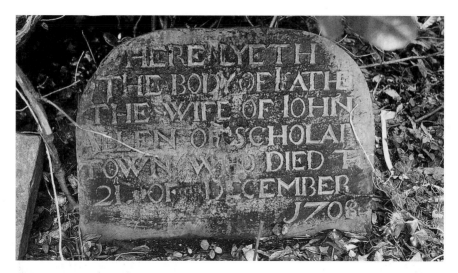

Rathfarnham churchyard. A 1708 headstone with the inscription 'here lyeth the body of Kathleen the wife of John Allen of Scholars Town, who died 21 December 1708'. (Courtesy of Michael Fewer Collection/South Dublin Libraries)

George Grierson (1709–1753), King's Printer in Ireland. He lived in Rathfarnham House and is buried in Rathfarnham Graveyard. (Courtesy of South Dublin Libraries)

The atmospheric interior of Rathfarnham Village old graveyard, 1992. (Courtesy of Patrick Healy/South Dublin Libraries)

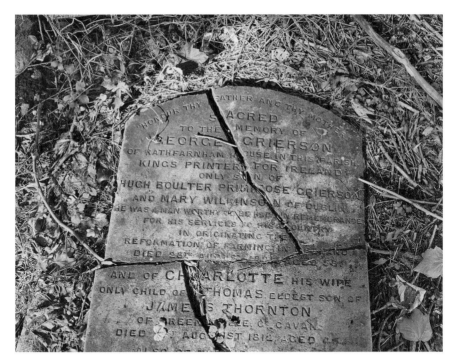

King's Printer for Ireland headstone, Rathfarnham graveyard. The broken engraved headstone in Rathfarnham graveyard containing the inscription 'Honour thy father and thy mother' and 'Sacred to the Memory of George Grierson of Rathfarnham House in this Parish. Kings Printer for Ireland'. (Courtesy of Michael Fewer/South Dublin Libraries)

A point of interest in relation to the graveyard is that it has been noted that the original *ráth* that gave its name to Rathfarnham, is sited at the rear of the graveyard. There is a steep drop from this area down to the River Dodder.

CHURCH LANE VIEW

Immediately adjoining the church on Main Street is Church Lane at the corner of which is a bank built on the site of the Rathfarnham Royal Irish Constabulary barracks that was burned down during the Irish War of Independence in 1922. In the lane is an old blocked-up doorway of early eighteenth-century design. Church Lane leads to Woodview Cottages, which can be seen from the brow of the lane, which are built partly on the site of an old paper mill. The mill race previously mentioned passed under Butterfield Lane to the paper mill and continued on below Ashfield to turn the wheel of the Ely Cloth Factory. It later flowed into the Owendoher River at Woodview Cottages. Until recently, when the new road was made to Templeogue, the old mill race could still be traced through the grounds of Ashfield where its dry bed was still spanned by several stone bridges. The cottages stand at the bottom of the hill, surrounded by woodland, with the River Dodder passing nearby and with views of the Dublin Mountains. These cottages stand as a reminder of an important stage in the development of the village with the influx of workers' terraces which have become emblematic of the wider area.

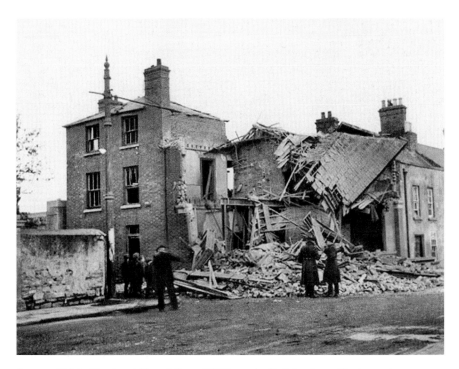

Corner of Main Street and Church Lane. RIC Barracks, Rathfarnham. The barracks was destroyed during the War of Independence. The site is now occupied by a bank. (Courtesy of South Dublin Libraries Local Studies Section)

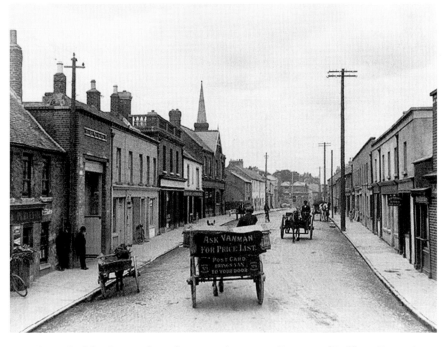

Main Street, Rathfarnham in the early twentieth century. (Courtesy of Dublin.ie Forums)

ASHFIELD HOUSE

Just down the road from the old graveyard is Ashfield House (in the heart of the Brookvale housing development). Ashfield was occupied by the Protestant clergy during the eighteenth century. In the early part of the twentieth century it was the home of Sir William Cusac Smith, Baron of the Exchequer until 1841, when it passed to the Tottenham Family who continued to reside there until 1913. After this

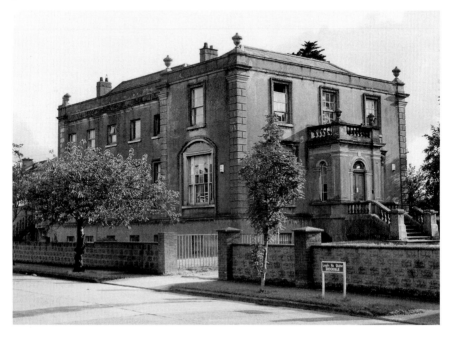

Ashfield House, Brookvale Road, Rathfarnham. A detached three-bay two-storey over basement former country house with a five-bay wing to the south. It was built *c.* 1800. It was refurbished and a porch was added around 1860. (Courtesy of Historic Pics.Inc)

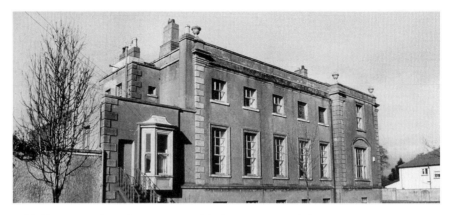

Ashfield House, Rathfarnham, 2004. A glebe house, it was built between 1790 and 1820, and is located just off the Rathfarnham Road as one approaches the village. Ashfield House was later known as Brookvale and gives its name to Brookvale Downs. (Courtesy of Michael Fewer/South Dublin Libraries)

it was occupied by the Brooks family of Brooks Thomas Ltd, the timber and builder suppliers until about twenty years ago, when the estate was divided up and houses built along the main road. A new road was later built along the side of the house and named Brookvale after the last occupants.

COURTS, CHURCHES, CHEMISTS AND CRUMBS

There are some fine buildings and terraces in the village which still retains some of its old-world charm. However, on approaching the village from the north, one's attention is distracted by the modern red-brick Rathfarnham Credit Union building that seems to tower over the village at this point. And, unfortunately, it partially blocks the view of the magnificent Dublin Mountains behind. Behind this building the Loftus Square apartment block, built between 1995 and 1998, similarly towers over the village. Adam Loftus, Milo le Bret and the castle architect, James Blackbourne, are remembered with place names in this apartment complex. The small development of terraced houses at Village Green, just before the old graveyard, is a gentle reminder of good planning.

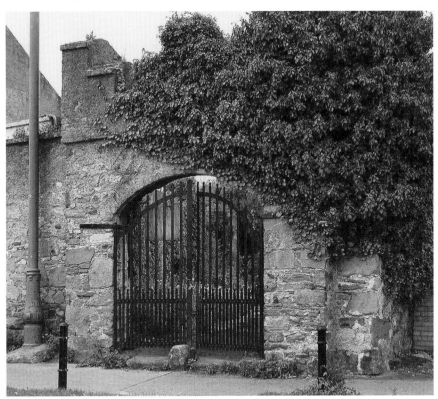

Rathfarnham village graveyard (*c.* 1720), containing the ruins of a former church (*c.* 1600). The graveyard also contains a collection of headstones and tombs dating from the early eighteenth century onwards and is still in use. This site has a rich history, having changed from Catholic to Church of Ireland in the post-Reformation years. (Courtesy of South Dublin Libraries)

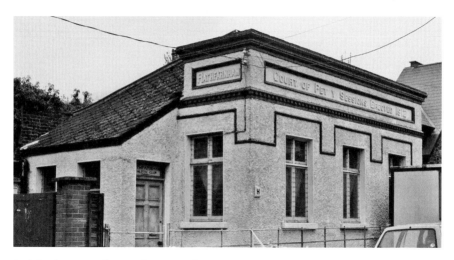

Rathfarnham Courthouse: The Court of Petty Sessions on Main Street was built in 1912. Today, the original public entrance has Rathfarnham Athletic Club above the door. (Courtesy of Patrick Healy/South Dublin Libraries)

Bordering the village pavements of Main Street are the old cobblestones – a reminder of a different era. At one end is the 1912-built courthouse, this little building was built as the Court of Petty Sessions. The Courts of Petty Sessions were forerunners of our modern-day District Courts. This building served as a courthouse until the Boys' School in Willbrook Road became available and was converted to a courthouse.

Across the road is the quintessential old village church – the Church of Ireland building. The ornate vicarage, next to the church, is on Main Street at No. 9. Further along, beside Hilton's Pharmacy, we have Rowans Delicatessen which has been a popular family business since 1932. Today it still thrives under the able management of owner Barry Rowan (for sixty-two years so far!), a man full of stories and memories of all things Rathfarnham. He can recall the names of all the local butchers and the local slaughterhouses and how every Wednesday morning in the old days Rathfarnham village was like the Wild West as cows disembarked from their carriers and ambled to where 'they knew where they were going'!

Just passed Rowans, we have Doddervale, a horseshoe-shaped cul-de-sac and quiet enclave of terraced houses. The poet, critic, and theatre director F.R. Higgins (1896–1941) lived here for a short time from 1932, before moving to a bungalow at No. 39 Lower Dodder Road. Past this junction is the post office with the old Irish lettering still in place, giving some indication of its longevity. Here the postmaster and his family are still dispensing stamps after nearly seventy years! The entrance, with its stained-glass panels, and the floor with the original floor tiling, are nice features of the post office.

Beyond the post office is a terrace of three red-bricked houses (Nos 16, 17 and 18 Main Street) erected in 1904. The brick detail and arches are worth noting. These two-bay two-storey houses of red and yellow brick formation have additional decorative details above windows and doors. It is an example of earlier building of distinct and individual character being adapted to suit modern need. Daly's Terrace, as it was known, still receives correspondence from the Revenue and the Rates Office addressed to Daly's Terrace!

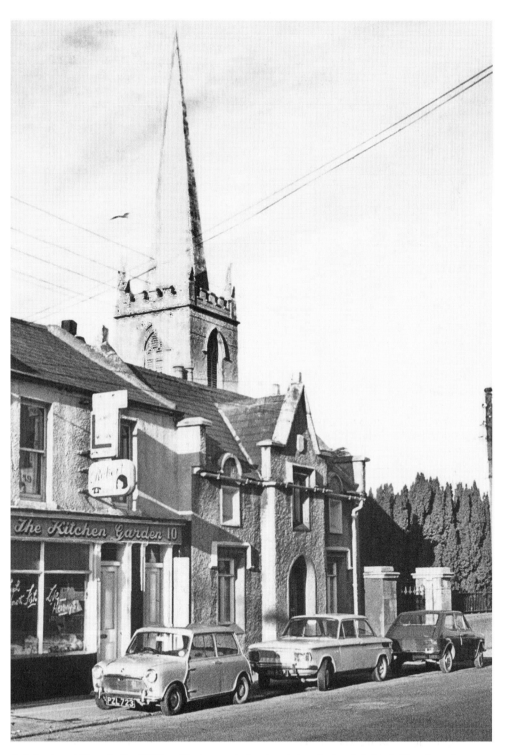

Rathfarnham Village in the 1980s with vicarage in front and church steeple behind. (Courtesy of Patrick Healy/South Dublin Libraries)

Cosgrave's Butcher, with its ornate roof balcony, is at No. 20 and is another long-established family business that continues to prosper since the 1930s. There is an interesting old photograph inside of the family shop in Ranelagh with the many staff standing outside, cattle arriving and carcasses hanging up outside.

The old firm of J.C. Walsh is at Nos 23/24 and has been a gift shop since 1946. For many years it was one of the main manufacturers and suppliers of rosary beads in Ireland. It continues to make high-quality marble gift items, jewellery and souvenirs, created by top designers, in its factory behind the colourful and inviting shop on the Main Street. Interestingly, the business own and operates its own quarry in Lissougter, Recess, County Galway. From here, 900-million-year-old Connemara marble is extracted and transported to Rathfarnham for crafting and polishing. Beyond Walsh's and down a steep incline we see and hear a tributary of the Dodder River as it makes its way under Butterfield Avenue, across from Rathfarnham Garda Station, and under the bridge beside the village.

Across the road from Walsh's at No. 36 is Greene's Pharmacy, dating from 1922. It has a bowl and pestle – the apothecary's sign – in stained glass over the entrance. Inside there is an old framed photograph showing the funeral of former Taoiseach, W.T. Cosgrave, as it passed through the village in 1965.

Further along are some more long-standing and landmark businesses such as the Revel's pub and the Castle Inn with its fine stone-worked frontage. These decorated pubs are well-worth a visit, each more interesting than the one next door. The Castle Inn has a very distinctive wall frontage. The interior is made of stone and light wood and is one of the newer pubs in Rathfarnham. It also has a rare vinyl collection adorning its interior wall and is decorated in a particularly imaginative fashion. Next door in the Revel's, also well decorated, is a framed photograph of the Ballyboden Gaelic Football Team from 1928.

Modern buildings have been constructed on this side of the street and these have drawn influence from the village's older designs. This includes techniques such as the use of yellow brick or the use of architectural designs that are reflective of its medieval past.

A statue of Anne Devlin stands at the end of the Main Street of Rathfarnham, looking in the direction of Butterfield Avenue. This statue, by sculptor Clodagh Emoe, was officially unveiled by Lord Mayor Maire Ardagh of South Dublin on 4 March 2004, the anniversary of Robert Emmet's birth. Anne worked with Emmet in Butterfield Avenue where he planned the 1803 Rising and she suffered imprisonment and torture in the aftermath of its failure. The sculpture was realized through the efforts of the residents of the Rathfarnham area and was grant-aided by South Dublin County Council.

Interestingly, the short terrace of whitewashed buildings just behind the statue, is called Wolfe Tone Terrace, and named after fellow-United Irishman, Wolfe Tone of 1798. MacCarthy Auctioneers has a plaque on its upper wall with an old inscription, 'Wolfe Tone House'.

There is a slip of a road, from the end of the village to the beginning of Butterfield Avenue that is worth a look. For it is here that one can stop a while and look over the parapet of the bridge and ponder the impressive Owendoher River making its way under the bridge and behind the village, towards the Dodder.

Across the road, between the Village Court apartments and the Yellow House, we have St Mary's Terrace, a fine row of red-bricked houses, built in the early twentieth century. The Corner Shop has been a local landmark for many years.

The ornate No. 18 Daly's Terrace, Main Street in the mid-1990s. This end-of-terrace two-bay two-storey house was built in 1904 and is now in use as office. (Courtesy of South Dublin Libraries/Michael Fewer/PH)

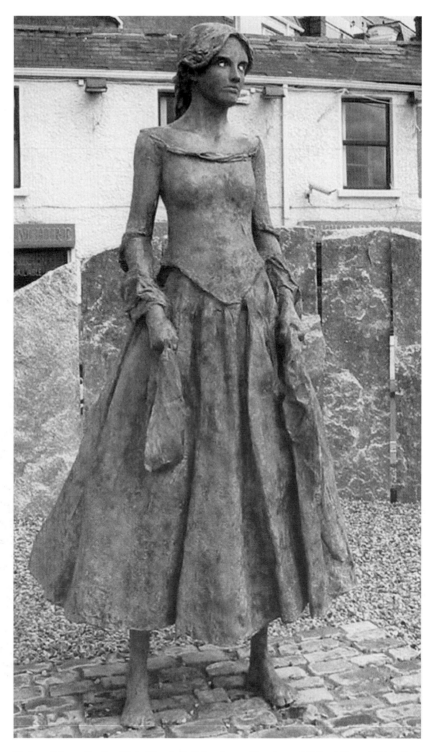

Statue of Anne Devlin, Main Street, Rathfarnham. (Courtesy of Robert Emmet Historical Society/Rathfarnham Our Villages/SDL)

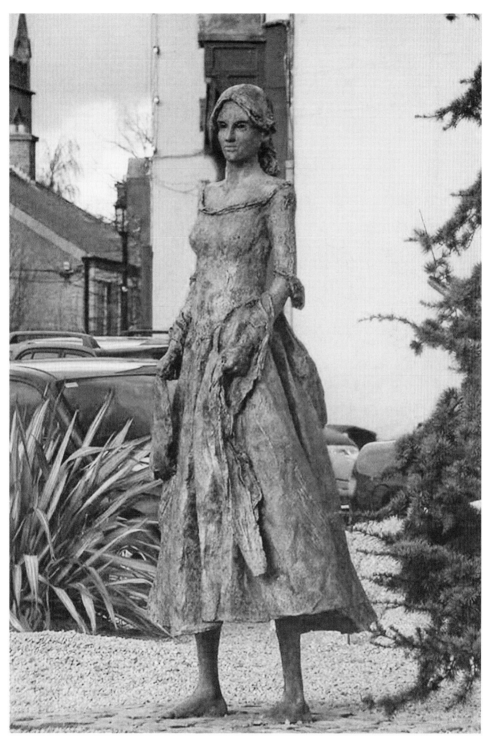

Another view of the statue of Anne Devlin. (Courtesy of Robert Emmet Historical Society/
Rathfarnham Our Villages/SDL)

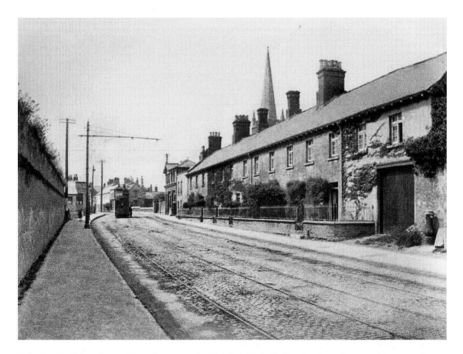

Entering Rathfarnham village from south, 1880–1900. Notice the tramlines and tram with Church of Ireland steeple behind police barracks. (Courtesy of National Library of Ireland)

Just around the corner is another interesting terrace of dwellings, St Mary's Avenue. In fact, the hidden terraces, with their nooks and crannies, on both sides of the Yellow House are well worth a visit given their attractive and atmospheric styles and peculiar locations.

THE YELLOW HOUSE AND 1798

On the corner of Willbrook and Grange Roads, and opposite the Catholic church, is the well-known Yellow House, a licensed premises built on the site of an inn of the same name which is marked on Taylor's map of 1816. It is also at the start of the Military Road which commenced from that point and ran as far as Aughavannagh, in County Wicklow. The road was built between 1800 and 1809 under Alexander Taylor. It included a series of barracks in the Wicklow Mountains and was intended to control an area that had sheltered the survivors of the 1798 Rebellion. Some say the pub was used during the rebellion as a meeting room for the rebel leaders, some of whom lived in Rathfarnham. A Michael Eades is recorded as owning the original pub premises in 1798 and gave shelter to United Irishman, who eavesdropped on soldiers of the Rathfarnham Guard there. In retaliation for this the soldiers trashed the premises in 1804. The present premises was constructed in 1825 by Mary Murphy. It was operated from 1912 to 1979 by the Walker family and finally came into the possession of the Durkan brothers who extended and refurbished it.

According to local folklore, the poet Francis Ledwidge worked there for two days as an apprentice before homesickness for his home town of Slane, County Meath,

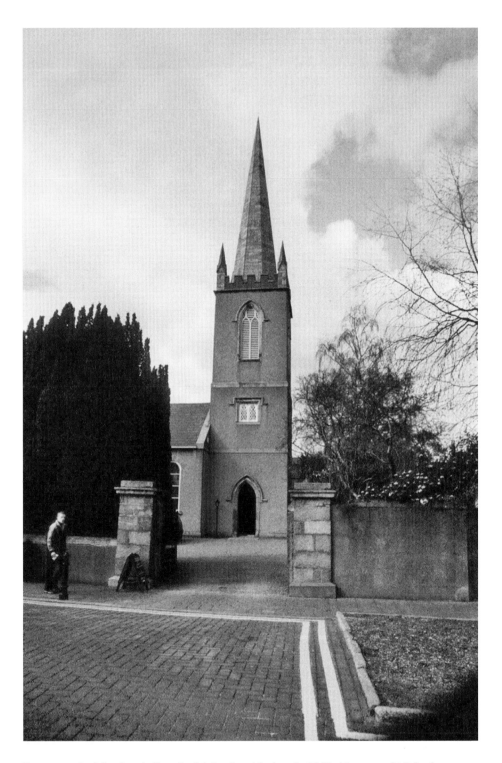

Entrance to Rathfarnham's Church of Ireland parish church, 2003. (Courtesy of Michael Fewer/South Dublin Libraries)

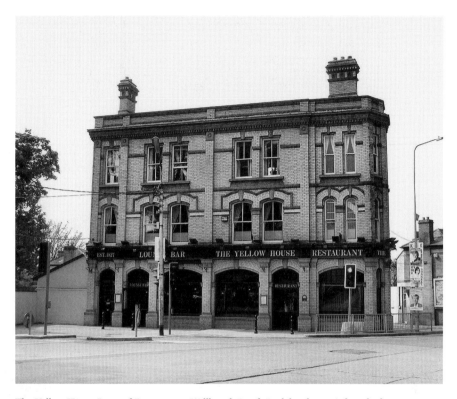

The Yellow House Bar and Restaurant, Willbrook Road, Rathfarnham. A detached three-storey public house and restaurant, it was built around 1885, with four irregular bays to east and a three-sided bow end. (Courtesy of South Dublin Libraries/The Yellow House)

caused him to leave. Still on matters literary: a little-known fact about the Yellow House was a meeting of writer James Joyce with his father, the result of which was reconciliation after years of discord.

THE NO. 16 TRAM

A horse-drawn tram service from Dublin City via Harold's Cross to Terenure began on 22 June 1879, run by the Dublin Central Tramways Company. Tramway Cottage in Terenure village, next door to the old Classic Cinema premises of 1938, derives its name from this time. Soon this service extended to Rathfarnham. Two years earlier a horse-drawn tram service from Nelson's Pillar to Drumcondra had been opened by the North Dublin Street Tramway Company and the entire line was electrified from the 9 November 1899. The service to Rathfarnham was the No. 16 and had a green Maltese cross as its symbol. It was served by depots at Phibsborough and Terenure. On 1 May 1939 the tram service was replaced by a bus service, also designated the No. 16.

A former resident of Rathfarnham, Prionsias O'Duffy, a national school teacher, writing in 1938, reflected on meeting the 1916 Rising leader Patrick Pearse at the terminus of the No. 16 tram, on a wet September afternoon about twenty-five years previously. The terminus then was outside the graveyard:

It's a dog's life! Driver of motorbike shows CIE the way to Rathfarnham on the No. 16A bus! (Courtesy of Dublin.ie Forums/El Gronk)

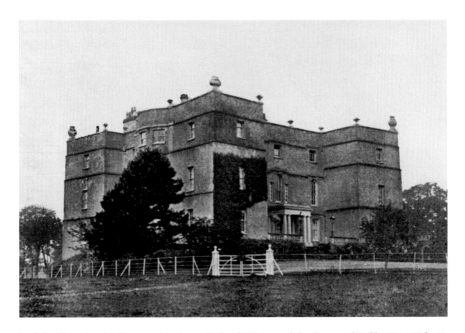

Rathfarnham Castle. (Image taken from the book *History of the County of Dublin*, Part II, by F. Elrington Ball (1903). Courtesy of CCL/OPW)

The drizzly rain made Rathfarnham look more forlorn than ever [and he saw] a stoutly built young man with a tweed hat pulled down around his head. His face had the strong colour of health usually associated with an outdoor life, steady blue grey eyes, a strong nose showing the nostrils, from front strong lips and firm chin closely joined to chest – more a worker it seemed than a thinker ... and then the thinker's forehead became visible. 'Tráthnóna fliuch' [wet afternoon] he said ... The tram started.

4

ROUTES AND ROADS

There are a number of important roads radiating from and leading to Rathfarnham Village. These include Rathfarnham Road, the Dodder Roads, Butterfield Avenue, Willbrook Road, Nutgrove Avenue and Grange Road.

RATHFARNHAM ROAD AND PEARSE BROTHERS BRIDGE

It is believed that the road to Rathfarnham follows the same route as the ancient highway known as the Slighe Chualann. It was part of a system of roads dating from pre-Christian times that was centred on Tara, County Meath, the seat of the

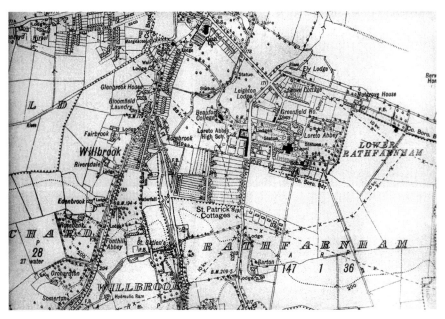

Nineteenth-century map of Rathfarnham. (Courtesy of Patrick Healy/South Dublin Libraries)

Irish High Kings. The Slighe Chualann was used by those travelling between Dublin, Wicklow and Wexford and is believed to have crossed the River Dodder at the Big Bridge, now Pearse Bridge, and re-crossed it again near Oldbawn.

The first record of a bridge here dates to 1381 and in 1652 it was described by Gerard Boate in his *A Natural History of Ireland* as a wooden bridge which, 'though it be high and strong nevertheless hath several times been quite broke and carried away through the violence of sudden floods.' Flooding on the river resulted in the demolishing of three bridges between 1728 and 1765. In 1765 the present structure, a single stone arch, was erected. It was widened and renamed in 1952 in commemoration of Patrick and William Pearse, leaders of the 1916 Rising, who had strong links with Rathfarnham through St Enda's School.

In 1912, during the construction of a main drainage scheme to Rathfarnham, a stone causeway was uncovered 23ft (7m) below the road level. It was 9ft (2.7m) wide and built of great blocks. Cut into the surface of the stone were a number of deep parallel grooves, gouged from the action of wheeled traffic over a long period. This was evidence for the existence here of a busy thoroughfare even before the construction of the earliest bridge.

The low-lying fields on the west side of the road, just beside the bridge, were formerly occupied by a mill pond and extensive mill buildings. On a map by Frizell dated 1779 it is called the 'Widow Clifford's mill and mill holding' and in 1843 it is named as the 'Ely Cloth Factory'. It was then owned by a Mr Murray but in 1850 passed into the hands of Mr Nickson, who converted it into a flour mill. His family continued in occupation until 1875 when John Lennox took over. In 1880 this mill closed down, the buildings were demolished and not a trace of it now remains.

Housing developments such as Rathfarnham Park, Ballytore Road, Crannagh, Castleside and Brookvale Downs, are accessible on each side of the main road to Rathfarnham Village. Most of these elevated dwellings are built on former castle lands.

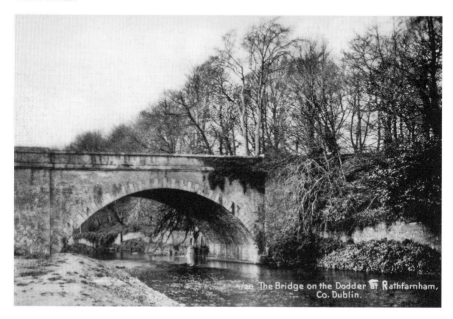

Bridge on the River Dodder, *c.* 1930. (Courtesy of South Dublin Libraries)

Crannagh, Ballytore and Rathfarnham Park were built around 1938–1946 and are Stringer homes of some quality and design. These houses occupy a mature, superb position on prime, peaceful and quietly exclusive roads. Some of the houses are substantial and detached with a secluded atmosphere. The particularly impressive family homes are pleasantly situated in this prestigious enclave, enjoying not only splendid views of the Dublin Mountains, the Dodder Park, Rathfarnham Castle or the Castle Golf Club, but are wonderfully located near Rathfarnham village itself.

LOWER DODDER ROAD/DODDER PARK ROAD/ DODDER VIEW ROAD

To the east of Pearse Bridge is Lower Dodder Road, following the course of the Dodder downstream to Orwell Bridge. This is part of the Dodder Valley Linear Park and it is possible to either walk or cycle along by the river from Firhouse to Ringsend. Parallel to the river in Rathfarnham we have Dodder Park Road. And going in the opposite direction, towards Templeogue, we have Dodder View Road. There are fine scenic dedicated walking routes along the banks of the Dodder if you go in either direction from the bridge.

Going east at the bridge at Lower Dodder Road you pass the old cottages, St Agnes's Terrace, adjacent to the bridge and below road level on your left. The river itself flows from Kippure Mountain to the River Liffey at Ringsend. The river is still prone to flooding and local residents recall the devastation it caused at the time of Hurricane Charley in the mid-1980s. Today, there is a very active Dodder Action Group who make a big effort to keep the river clean. Members of the Dodder Angling group are frequently sighted fishing along the banks and the weirs. There is a famous painting called 'On the River Dodder near Rathgar', painted in the early nineteenth century by the artist John Campbell, depicting the picturesque setting of the Dodder, a setting that has changed

Fishing on the banks of the River Dodder in the early twentieth century. (Courtesy of HX History Society)

little over time. It was in a house bordering the Dodder at Lower Dodder Road that the poet, critic and theatre director, F.R. Higgins lived for many years. He deliberately sought a house here as he loved water. He lived directly opposite a weir (in house called 'Durlas' at No. 39) and the sound of the cascading water could be heard from his house. At the same time, the poet, Austin Clarke, lived a mile upstream at Bridge House, Templeogue.

ELY'S ARCH

Beside the Dodder footbridge, and facing an open green space on this road, is a fine entrance gateway called Ely's Arch, across the road from the houses of Woodside, built in the form of a triumphal arch and originally leading into Rathfarnham Castle. The erection of this gateway is attributed to Henry Loftus, Earl of Ely from 1769 to 1783 who also was responsible for the classical work at the castle itself. This is named the 'New Gate' on Frizell's map of 1779. After the division of the estate in 1913, this became the entrance to the Castle Golf Club but it was later abandoned in favour of the more direct entrance at a corner of Woodside Drive. In 1841 this place was the scene of a brutal murder, when the dead body of an Italian named Garlibardo was found lying on the open ground in front of the gate. Although arrests were made at the time, no one was convicted of the murder. The spot was later marked with a cross.

The area around the arch is a haven for wildlife, with the nearby River Dodder home to brown trout, otter and many water-birds including kingfisher, dipper and grey heron. Woodside Estate is home to red fox, rabbits and grey squirrels.

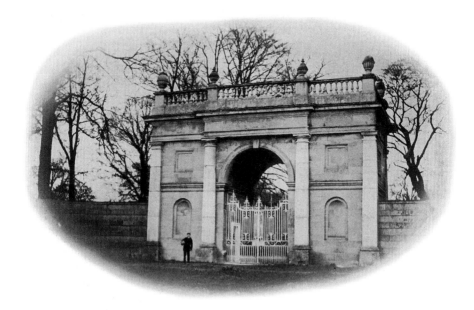

Entrance to Rathfarnham Castle. (Image taken from the book *History of the County of Dublin*, Part II, by F. Elrington Ball (1903)/OPW)

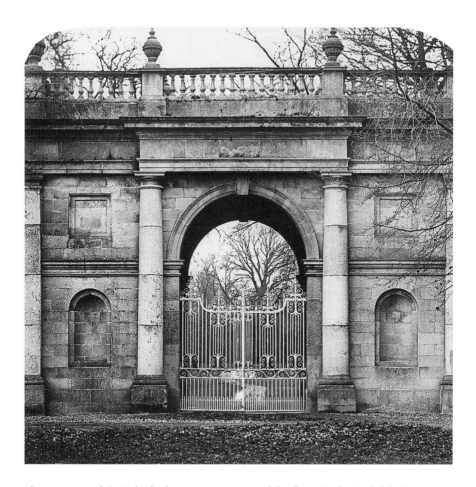

The impressive Ely's Arch, the former entrance to Rathfarnham Castle. Lord Ely's Gate, as it was originally known, was erected around 1770. The original photo was taken with a glass plate/latern slide. (Courtesy of Charles Russel/South Dublin Libraries)

THE PLAYBOY AND JOHN MILLINGTON SYNGE

The playwright, J.M. Synge (1871–1909) was born just beyond the arch, at 2 Newtown Villas, Rathfarnham. This was a large, grey semi-detached house in its own grounds with a view of the Dublin Mountains in the distance. He was literary advisor and director of the Abbey Theatre, along with W.B. Yeats and Lady Gregory. His comedy *The Playboy of the Western World* is now a classic of the Irish theatre, but it caused a riot on its first production in the Abbey in 1907. His other plays include *Riders to the Sea* and *In the Shadow of the Glen*.

John Millington Synge (1871–1909), playwright, spent his early years living near the River Dodder.

WOODSIDE AND WHITEHALL

Opposite Ely's Arch is the steep entrance drive to Woodside and Hillside roads. On the way towards the Castle Golf Club there are some splendid detached houses and bungalows. Forget Ballsbridge, this oasis of tranquility and elevated beauty is a treat to traverse. The tree and shrub-lined roads have residences that vie with each other to be more distinctive and more impressive – and they succeed!

THE BOTTLE TOWER

Continuing along Hillside and passed the entrance to the Golf Club, we come to the winding and picturesque Whitehall Road, lined with bungalows and where stands that curious structure known as the Bottle Tower or Hall's Barn. This was built by Major Hall in 1742 in imitation of the better constructed Wonderful Barn erected about the same period near Leixlip. The floors and other timber work have long disappeared and the winding stone steps are not considered safe to ascend. While the ground floor may have been used as a barn, the first and second floors appear to have been residential as they are both fitted with fireplaces. A smaller structure behind the barn, built on somewhat similar lines, was a pigeon house. The old house named Whitehall, which was demolished some years ago, stood adjacent to the barn. It was also built by Major Hall about the same time. In 1778 it was the residence of Revd Jeremy Walsh, curate of Dundrum, and in 1795 it was converted into a boarding house. A newspaper advertisement in 1816 invites enquiries from prospective visitors. In a description written in the last century the old-fashioned kitchen and panelled staircase are specially noted.

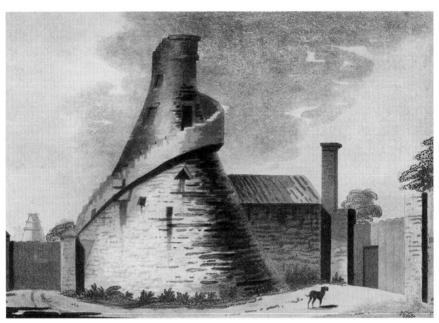

Sketch of The White Barn (The Bottle Tower), Whitehall Road, in 1795. (Courtesy of Dublin.ie Forums/ab)

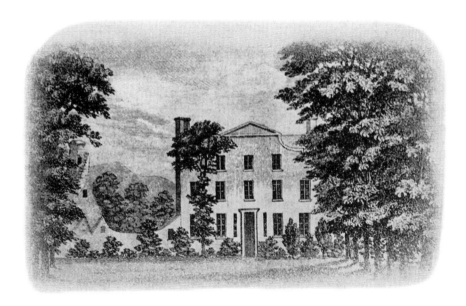

Berwick House, Rathfarnham. (Courtesy of Thomas Mason/South Dublin Libraries/Loreto Sisters)

BERWICK HOUSE AND HAZELBROOK

Just beyond the Bottle Tower is a formidable-looking tall house at the bend in the road. This was recently occupied by the de la Salle Brothers. In 1836 it was known as Hazelbrook (after Hazelbrook Farm in Limerick/Clare), a name which was later transferred to the nearby milk bottling plant, and has given its title to what is now a great industry – Hughes Brothers milk and ice cream, or HB as it is more commonly known. From 1844 to 1899 it was known as Bachelor's Hall, after which it became the headquarters of a charitable institution, the Berwick Home. In 1944 it again became a private residence and the name was changed to Berwick House. In the late twentieth century, the milk-bottling plant moved its operations elsewhere, but the name Hazelbrook lives on in a large apartment complex near the junction with Nutgrove Avenue.

NUTGROVE AVENUE

Whitehall brings us to Nutgrove Avenue, widened and extended in the 1960s, that links Rathfarnham with Churchtown. The old quiet tree-shaded avenue has been completely swept away. It was a cramped passage, bounded on both sides by towering walls and full of right-angled bends, which wound its crooked course between Loreto Convent Cemetery and the garden of Nutgrove House. Until about 1911, a massive gateway stood at the entrance to this avenue which bore the inscription 'Nutgrove School Established 1802'. In 1839 this school was under the supervision of Mr Philip Jones, who continued to hold the post of principal until 1866, when the position was held by Mrs Anne Jones. In 1876 the school closed down and the house

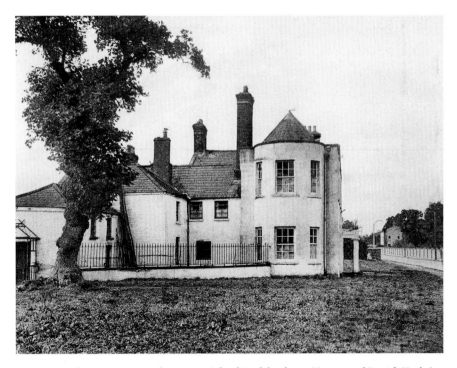

Early twentieth-century image of Nutgrove School, Rathfarnham. (Courtesy of Patrick Healy/ South Dublin Libraries)

was occupied as a private residence by various tenants until recent years, when it became the headquarters of the parish council.

Joyce, in his *Neighbourhood of Dublin*, states that Nutgrove House was at one time the dower house of Rathfarnham Castle but in this he is almost certainly mistaken, as Frizell's map of 1779 shows that it was outside the estate. It is possible that he confused it with the other old house on the opposite side of the avenue which was formerly named Ely Cottage, later altered to Ely Lodge, and which was shown as within the boundary of the estate. Ely House is the last of the fine original houses remaining on Nutgrove Avenue.

THE PONDS

At the junction of Nutgrove Avenue and Grange Road we have Loreto Terrace with a open green area in front. On the north side of the imposing and impressive Loreto Abbey, this area was formerly known as The Ponds, a name originating apparently from the large pond which 200 years ago occupied what was a low-lying field between Loreto Terrace and Nutgrove Avenue. This area was described in Joyce's *Neighbourhood of Dublin* in 1912 as, 'the dilapidated locality known as the Ponds'. The last of the old houses was demolished in the mid-1980s. It was a very early eighteenth-century gabled residence named Grove Cottage and was reputed to be the oldest occupied house in Dublin. This was the site of a skirmish at the outbreak of the rising of 1798. The insurgents of the south county assembled at the Ponds on 24 May 1798 under the leadership of David Keely, James Byrne, Edward Keogh and

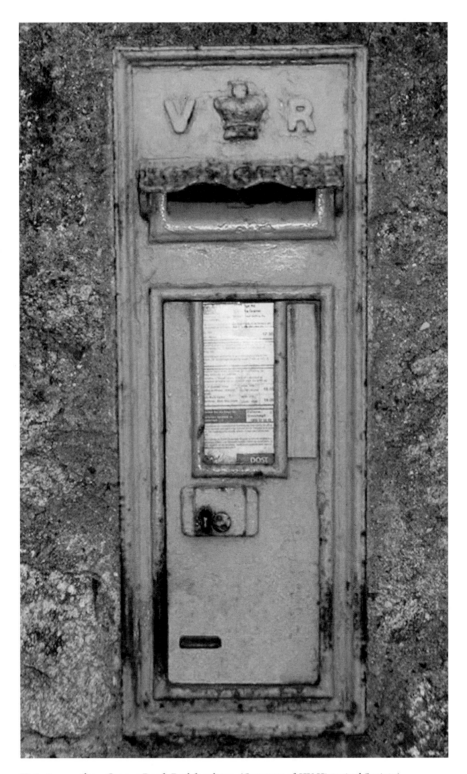

Victorian postbox, Grange Road, Rathfarnham. (Courtesy of HX Historical Society)

Edward Ledwich. The latter two had been members of Lord Ely's yeomanry but had taken to the field with the United Irishmen. The insurgents were attacked by the local yeomanry corps but were able to defend themselves and the yeomanry were forced to retreat. A party of regular troops were then sent against them and a stiff encounter took place. A number of the insurgents were killed or wounded and some prisoners taken, including Keogh and Ledwich. The survivors retreated to join up with a party from Clondalkin and a further engagement took place at the turnpike on the Rathcoole road, where the enemy were successfully repulsed.

The Nutgrove Shopping Centre and Loreto Park (Nutgrove), the recent housing and apartment complexes and shopping centres, are all relatively recent additions to the vibrant Avenue.

FROM HOUSE TO ABBEY

Past the Ponds is the Grange Road and the imposing buildings of Loreto Abbey that form a remarkable landmark visible for many miles south of the city. The mansion, called Rathfarnham House, which now forms the centrepiece of the group, was built by Mr William Palliser about 1725. No expense was spared in its construction and decoration, as can still be judged by the beautifully preserved interior, the polished mahogany and, in one room, embossed leather wallpaper. On the death of William Palliser Rathfarnham House passed to his cousin, the Revd John Palliser, who was rector of the parish. After his death in 1795 the house was purchased by George Grierson (1709–1753), the King's Printer, who resided here for a few years. Among his productions were the first edition published in Ireland, in 1724, of *Paradise Lost*; Sir William Petty's *Maps of Ireland*; and other valuable works. His wife, Constantia, was regarded as one of the most learned scholars of her age.

When Grierson removed to his new abode in Woodtown the house remained unoccupied for some years until, in 1821, it was purchased by Dr Daniel Murray, Catholic Archbishop of Dublin, for the newly founded Loreto Order.

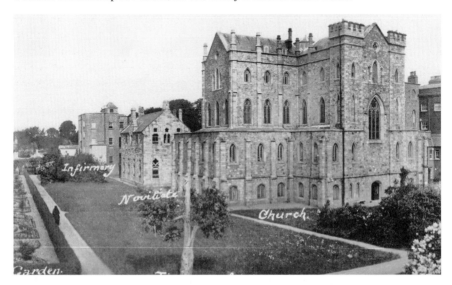

Early twentieth-century picture of Loreto Abbey. (Courtesy of Dublin.ie Forums/Loreto Sisters)

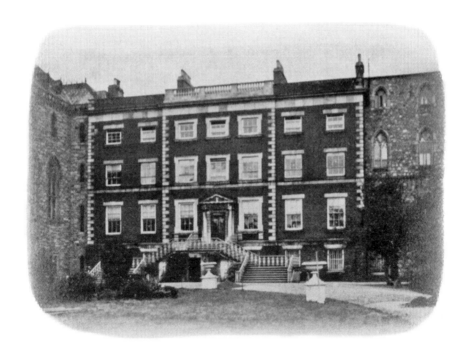

The Loreto Convent, Rathfarnham. (Courtesy of Thomas Mason/South Dublin Libraries/ Loreto Sisters)

Henceforth, it would be called Loreto Abbey. The foundress, Mother Mary Frances Teresa Ball (1794–1861), made many improvements to the house. Various additions have been made over the years – the church was built in 1840, the novitiate in 1863 and six years later the part named St Joseph's wing which contains the concert hall and refectory. St Anthony's wing was erected in 1896, St Francis Xavier's in 1903 and the Lisieux building in 1932 for the accommodation of the many visiting prelates and dignitaries to the 1932 International Eucharistic Congress which was held in Dublin. These additions flank the main central Georgian house. It total, the buildings are a veritable treasure trove of architectural gems from the beautiful church with its vaulted ceilings and stained-glass windows through to the abbey with its splendid plasterwork and impressive accommodation.

Queen Victoria visited the Sisters in the abbey during her visit to Ireland in 1900. The newspapers at the time reported on the visit. However, the term 'Reverend Mother' was a somewhat strange one in their minds and so in their report they called her, 'Mrs Corcoran'!

MOTHER TERESA OF CALCUTTA

One of the abbey's most famous protégés was Mother Teresa of Calcutta (1910–1997), who came to Ireland from Albania to join the order in 1928. She resided at Loreto Abbey during her early training to become a Loreto Sister. Mother Teresa subsequently became the foundress of the Missionaries of Charity. For many years in the late twentieth century she was an international figure, such was

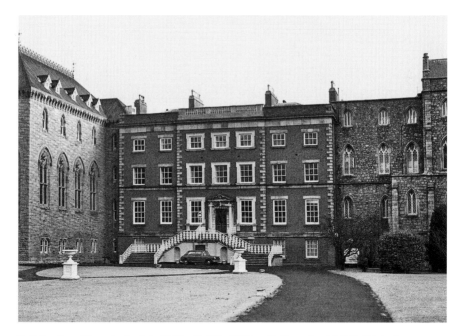

Rathfarnham House in the late 1970s. Built by William Palliser about 1725, it later became the Loretto Abbey. (Courtesy of Patrick Healy/South Dublin Libraries/Loreto Sisters)

her heroic work among the poor of Calcutta in India. She returned to the abbey and school more than sixty years later and what a welcome she received!

Loreto Abbey and the adjoining buildings, a classical collection of former college, school and church buildings, on 4½ acres, were bought in 1999 by the developer Liam Carroll. Nearly 300 apartments were built before the developer succumbed to the collapse of the so-called Celtic Tiger economy. The abbey and the adjoining buildings (which are listed structures) lay derelict for fourteen years before being sold again in 2013.

BEAUFORT HOUSE AND SCHOOL

Across the road from the abbey, in the grounds of Loreto High School, which was founded in 1925, is the impressive Beaufort House, now the headquarters of the Loreto Order in Ireland. The fine granite pillars of the former entrance to Beaufort House, on Willbrook Road, now flank the pedestrian entrance to Beaufort Downs estate. Beaufort House was originally the property of the Hodgens Family. *Lewis's Topographical Dictionary* of the early nineteenth century lists the occupant as one R. Hodgens; later, *Thom's Directory* (1854) names one Henry Hodgens. The Hodgens donated the lands for the nearby Church of the Annunciation, dedicated in 1878. Afterwards Beaufort House was owned by a family called McCabe. It is said that, during their occupancy, King George V and Queen Mary visited the house in 1912.

The Loreto nuns purchased the property in 1925 and opened a domestic college and day school for girls. The domestic college ceased to operate in 1981 but the school remains today. Like Loreto Abbey, the original house has been extended over the years. Such is the reputation of the school, with its very high standards in education

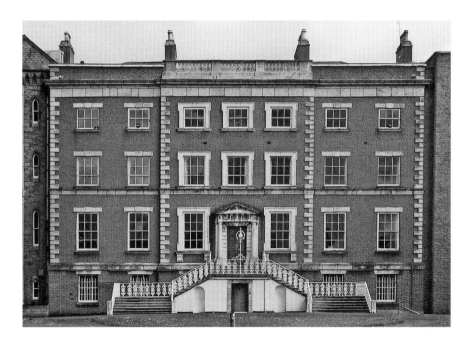

Rathfarnham House (later Loreto Abbey) was originally built around 1730 as a detached seven-bay three-storey over basement former country house, with shallow three-bay breakfront. It was used as a convent from the 1830s until around 1999. (Courtesy of the Loreto Sisters)

Loreto High School, Grange Road, Rathfarnham, established around 1925. (Courtesy of the Loreto Sisters)

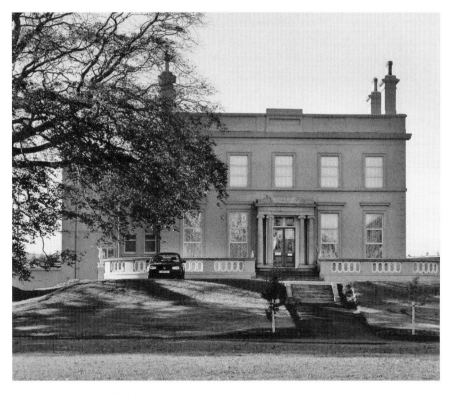

Beaufort House. Detached five-bay two-storey over basement former country house, *c.* 1850. Beaufort House was part of Loreto High School Beaufort, founded in 1925. It is now the headquarters of the Loreto Order. Robert Hodgens JP (1793–1860) followed by his sons, John Conlan Hodgens and Henry Hodgens, were former occupiers of Beaufort House. (Courtesy of Kieran Swords/South Dublin Libraries/Loreto Sisters)

and ideals, that to be known on the completion of one's education as 'a Beaufort girl' is one of the finest possible accolades!

FROM GRANGE ROAD TO TAYLORS THREE ROCK

The road from Beauford High School continues northward to the very distinctive Taylors Three Rock thatched pub, passed some very old houses which have been restored in recent years. The first is Snugborough, which has its gable end to the road. Just passed this we have the Washington Lodge (not to be confused with Washington House on Butterfield Avenue). The very picturesque St Patrick's Cottages are on the right-hand side. More of the cottages are also on Tara Hill Road/Grove that links Grange Road to Whitechurch Road. Here you will also find, if you can(!), a house called the 'Invisible House', with a cake-slice-shaped front garden.

In recent years, new avenues have been laid out here on both sides of the road, including Stonepark and Aranleigh, and Sarah Curran and Anne Devlin Roads on the right. Barton Drive, on the left, occupies the site of a house named Barton Lodge. On the other side is Silveracre, once the home of Dr Henthorn Todd, Professor of Hebrew in Trinity College Dublin, who was connected by marriage with the Hudson

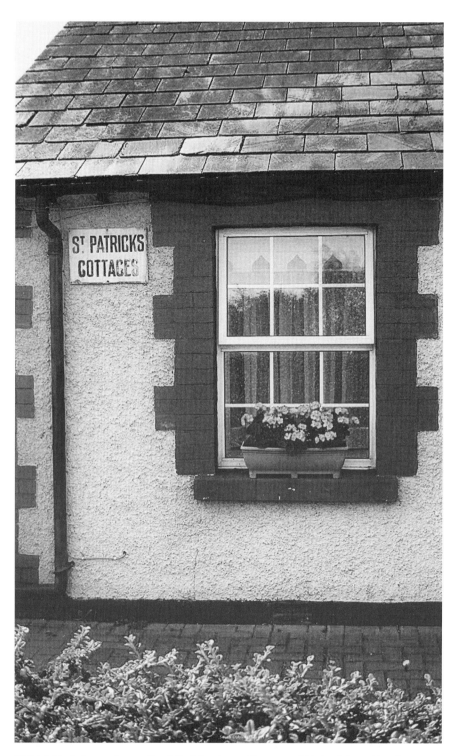

St Patrick's Cottages, Grange Road, Rathfarnham. (Courtesy of Michael Fewer/South Dublin Libraries)

family of the adjoining estate of The Hermitage. He was well known as an Irish scholar and was the editor and translator of a number of Irish documents as well as the author of a life of St Patrick. He died here in 1869. About the middle of the last century the name of the house was changed to Silverton but it was later changed back to the original Silveracre. Most of the land is now built on. It was also the home in the early part of twentieth century of Surgeon Croly, who founded Dublin's Baggot Street Hospital.

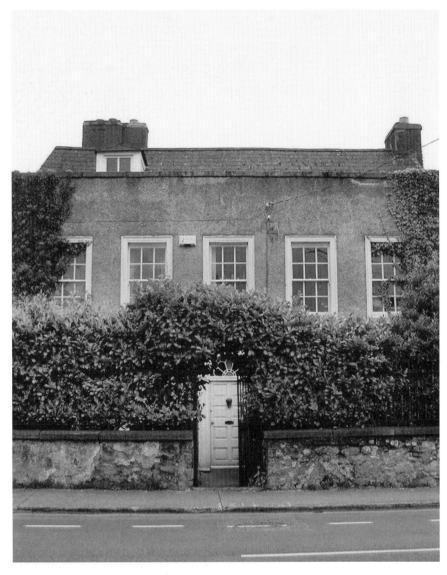

Washington Lodge, Grange Road, Rathfarnham. A detached five-bay two-storey with attic, this Georgian house was built around 1742. There is also a Washington House on Butterfield Avenue. (Courtesy of South Dublin Libraries/Dublin.ie Forum)

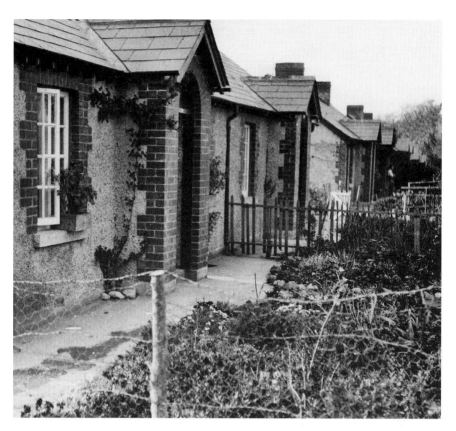

St Patrick's Cottages (built 1915) Grange Road. (Courtesy of John Byrne/South Dublin Libraries)

THE HERMITAGE

The Hermitage or St Enda's, as it is known today, is the former home and school of Patrick Pearse, the 1916 Rising leader. The house, which is entirely faced with cut granite and has an imposing stone portico, was occupied in the eighteenth century by Edward Hudson, an eminent dentist. He had a passion for Irish antiquities which he demonstrated in an unusual way by the erection of a number of romantic ruins around the estate. The pleasant grounds of St Enda's Park and the Pearse Museum are well worth a visit.

1916 Rising leader, Patrick Pearse. He was the founder of St Enda's School.

THE PRIORY AND ST PATRICK

Directly opposite St Enda's is the Priory, where once stood the home of John Philpot Curran (1750–1817), lawyer, nationalist and MP. A consistent supporter of parliamentary reform and Catholic Emancipation, Curran opposed the Act of Union and acted as defence counsel for leading United Irishmen. He was also a highly celebrated orator and wit and a noted duelist. The house, which played an integral role in Irish history at turn of the nineteenth century, and survived for 150 years, was renamed Priory when Curran bought it in 1790, in memory of his original home in Cork (although there is another interpretation of the name deriving from Curran being a member of the notorious drinking club, the Order of St Patrick. He was called 'the Prior' of the club!). He lived at the Priory for twenty-seven years at the peak of his fame and it was here he endured the tragic events which cast a shadow on his private life. First the untimely death of his daughter Gertrude, followed by the loss of his wife, who left him for another man, and lastly the discovery of the association of his daughter Sarah with Robert Emmet. Gertrude Curran had died in 1792 at the age of 12 as the result of a fall from a window. Curran had her buried in the grounds of the Priory and over the grave he placed a recumbent slab on which was fixed a metal plate bearing the inscription:

Here lies the body of Gertrude Curran
fourth daughter of John Philpot Curran
who departed this life October 6th 1792
Age twelve years.

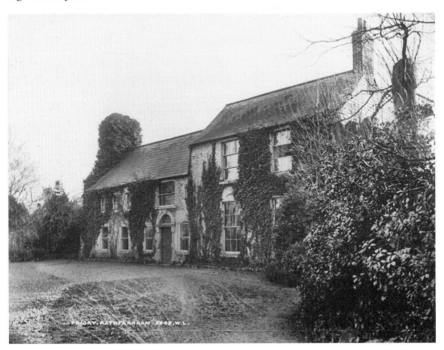

The Priory (since demolished) the former home of John Philpott Curran. (Courtesy of National Library of Ireland/Come here to me)

After the 1798 Rebellion he defended the United Irishmen Wolfe Tone, Napper Tandy, William Drennan and Hamilton Rowan. However, after the 1803 Rebellion he refused to represent Robert Emmet who had become privately engaged to his daughter, Sarah (1782–1808). Her name is remembered on nearby road. The relationship between Sarah Curran and Robert Emmet has been described as 'the greatest love story of Irish history'. Her tragic romance was featured in Washington Irving's *The Broken Heart* and in Thomas Moore's nostalgic air, 'She is far from the Land'. She died aged 26, her health having rapidly deteriorated since the execution of Robert Emmet in 1803.

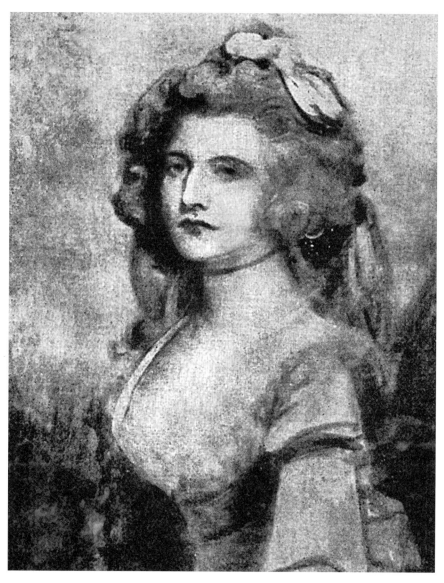

Sarah Curran, beloved of Robert Emmet, patriot. (Courtesy of Robert Emmet Historical Society Historical Prints)

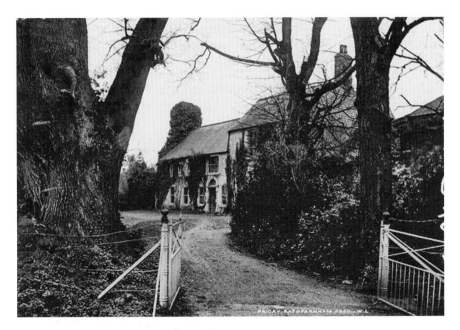

The Priory, opposite Marlay Park, before it was demolished. (Courtesy of the National Library of Ireland/Come here to me)

Due to Rathfarnham's strong links with Sarah Curran and Robert Emmet, it is not surprising to find a suggestion that the Priory was the last resting place of Robert Emmet. This tradition goes back for well over a century and it is rather surprising that this site was not investigated when the search for Emmet's remains was being made at places a great deal less accessible and no less improbable.

In October 1979 the opportunity offered itself to carry out this investigation. The Priory housing estate was being developed and heavy machinery moved in to lay the roads and sewers. Mrs Bernadette Foley of nearby Barton Drive drew attention to the need to carry out this work before the site was buried forever under new houses. With the co-operation of Messrs Gallaghers, the developers, a small group undertook to investigate the site, but to no avail.

Priory was occupied by the Curran family until 1875 and subsequently by the Taylors until 1923. At the beginning of twentieth century the house and gardens were still in good repair but after the Taylor's time the place was neglected. Soon only the walls were still standing and little now remains but some heaps of rubble.

It has been said that the house, besides playing a pivotal role in Irish revolutionary intrigue, was also linked to secret societies, wild parties, underground passages, fatal accidents, ghosts, secret rooms and a long-running quest for a forgotten grave. It has all the hallmarks of a fantastic melodramatic thriller.

HAROLD'S GRANGE AND TAYLOR'S LANE

Passed St Enda's and the Priory housing development, the Grange Road intersects with Taylor's Lane. Travelling left we pass Marlay Grange, the Eden Pub, the Three Rock Rovers Hockey Club and Marlay Park (with Marlay House) on our right. Passed

the park and staying to the right, Grange Road continues along by the walls of Marlay Park, passed Ballinteer St John's GAA Club and as far as Taylor's Three Rock Pub and the junction with Harold's Grange Road and College Road. There are some very attractive old and well-preserved cottages to be seen near this junction.

THE EDEN HOUSE

The Eden House pub is situated on Grange Road, near Marlay Park and is one of the highest pubs in Dublin. The beer garden was a favourite attraction because of the wide open spaces and the elevated views of the city. The building was formerly Eden House, one of the eighteenth-century stately houses on Grange Road, before being converted to its present use by Patsy Kiernan. The pub was then sold in 2006 for €5.5 million and is now run by owners of The Morgue Pub in Templeogue Village.

TAYLORS THREE ROCK

This landmark pub at the opposite end of Rathfarnham at the junction of Grange Road and Harold Grange Road is a particularly eye-catching building with an authentic taste of the past. Its thatched roof makes it the largest thatched roof structure in Ireland. Inside is a veritable imaginative museum with countless photographs showing the changing face of Ireland for over thirty-five years. The Taylors Irish Night, with the emphasis on traditional Irish music and cabaret, is a must for visitors and natives alike. The star of the cabaret for many years was the legendary Irish comedian Noel V. Ginnity, dubbed the 'king of cabaret' because of his ability to portray the wit and wisdom of Ireland.

BUTTERFIELD AVENUE

Butterfield Avenue links Rathfarnham village to Templeogue and Firhouse. There is a question over the origin of the name – did it derive from 'butter', due to the butter fairs that were held there, or '*bóthair*' (the Irish word for 'road')?

Formerly known as Butterfield Lane, it retained its rural character until the middle of this century but housing development, road widening and the removal of dangerous bends have now altered it beyond recognition. In this connection it is interesting to note that, on the map made by John Rocque in 1760, only four houses are shown on the entire length of the avenue. Until 1912 the only addition to these was a pair of council houses beside the bridge. These four houses are still standing and lend much to the atmosphere and character of Butterfield Avenue. The fairs of Rathfarnham were formerly held in Butterfield Lane.

Rathfarnham Golf Club started in 1898, close to the bridge at the village end of Butterfield Avenue, on lands belonging originally to Butterfield House. The club remained in this location until the 1960s, when it moved to its present location on Stocking Lane. More houses were then built on the lands of the former Golf Club.

Butterfield House dates from the late eighteenth century, probably around 1791, and the Andrews family were the first occupiers. It was once the home of John Hely Hutchinson, Prime Sergeant of Ireland, and later Provost of Trinity College.

Old Orchard House on Butterfield Avenue, 1990. (Courtesy of South Dublin Libraries)

Returning from a game of golf at Rathfarnham Gold Club in the early 1930s. (Courtesy of *Irish Independent*/National Library of Ireland)

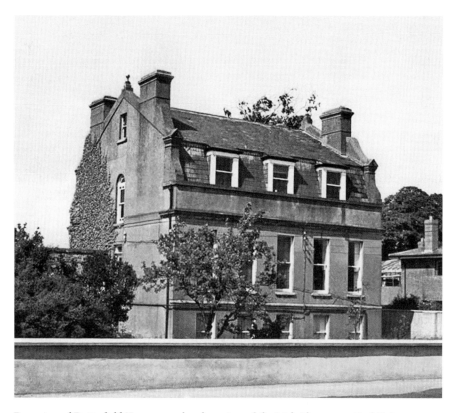

Rear view of Butterfield House, now headquarters of the Irish Pharmaceutical Union. (Courtesy of IPU)

Hely is accredited with the donation of a fair green to Rathfarnham Village in return for a high wall being built around his property. The house appears on the Ordnance Survey of 1843 and is listed in both *Thom's Directory* and *Griffith's Valuation* in the 1850s as being occupied by Mr Charles M. Dunn. It is an impressive structure with the unusual characteristic that its back fronts on to Butterfield Avenue, whereas its front must be accessed by a short winding driveway. The house has a mansard style of roof, with curved decorative gables. It is a particularly distinctive and attractive style and has been well-maintained over the years and in particular by its present owners. The style of interior plasterwork is of its era, as are the door surrounds, the staircase, and the decorative niches in some of the rooms. The original Adams fireplaces are gone, however, although there is an interesting Kilkenny marble fireplace in a small room off the hall. The house is now used as the headquarters of the Irish Pharmaceutical Union.

THE EMMET AND DEVLIN CONNECTION

Butterfield House is identified by some historians as the house occupied by the Irish patriot, Robert Emmet (1778–1803). Other houses along Butterfield Avenue also claim to have links with Emmet, including Old Orchard, Orchardstown House and Washington Lodge. Interestingly, Washington Lodge (now House) and the adjacent Washington Lane,

derived their name, according to locals, from the name being conferred on the house in 1799 by Robert Emmet to honour the memory of America's president, George Washington, who died in 1799.

In order to avoid being arrested before the 1803 Rising took place, Emmet rented one of these houses in April 1803 under the name of Robert Ellis and lived there with Dowdall, Hamilton and other United Irishmen. Some of the meetings arranged here were attended by the renowned and much-feared Wicklow chieftain and rebel, Michael Dwyer, and some of his men from the Glen of Imaal in County Wicklow. In charge of the housekeeping was Anne Devlin (her statue adorns Rathfarnham Village), whose father Brian Devlin had a dairy farm nearby.

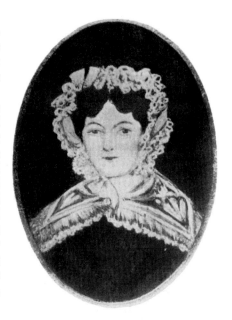

Anne Devlin (1780–1851), revolutionary. (Courtesy of HX History Society)

A YOUNG AND RADICAL PATRIOT

Robert Emmet joined the Society of United Irishmen while attending Trinity College. In 1802 he discussed Irish independence with Napoleon Bonaparte and Tallyrand in France. When he returned to Ireland he rented Butterfield House in Rathfarnham and became secretly engaged to Sarah Curran. He was determined to organise a rising and decided to act on 23 July 1803, with coordinated attacks on Dublin Castle, Pigeon House fort and Islandbridge barracks. The rebellion was disorganised and ineffective, and afterwards Emmet went into hiding in the Dublin Mountains. He was eventually arrested at Harold's Cross in August and tried for treason. Found guilty, he was hanged outside St Catherine's Church, Thomas Street on 20 September 1803, at the young age of 25. His famous 'Speech from the Dock' on the eve of his execution has been justly celebrated by generations of Republicans and Nationalists, and has assured him a lasting place in Irish nationalist folk history.

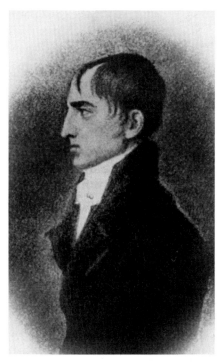

Robert Emmet (1778–1803), patriot. (Courtesy of HX History Society)

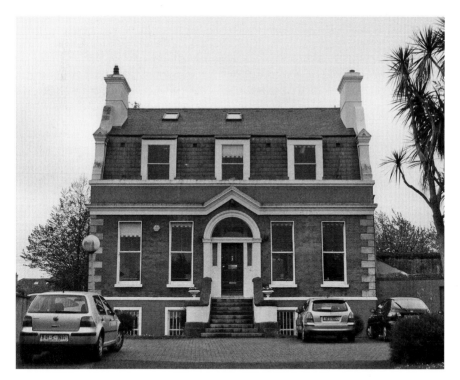

The front of Butterfield House, Butterfield Avenue, Rathfarnham. A detached five-bay single-storey over raised basement former country house, it was built around 1840 with high gable-ended mansard roof housing two attic storeys. It is now used as offices. Robert Emmet reputedly lodged here before the 1803 Rebellion, using the assumed name of Robert Ellis. (Courtesy of Dublin.ie Forums/Irish Pharmaceutical Union)

ANNE DEVLIN (1780–1851)

Anne was the devoted housekeeper of Robert Emmet and became an accomplice in his plans for rebellion. After the failed insurrection, Anne Devlin was arrested and tortured but still refused to give any information about Emmet. She was imprisoned in Kilmainham Jail for high treason and was not released until 1806. She lived for the rest of her life in The Liberties, not far from the scene of much of Robert Emmet's activities and subsequent death.

RUSTIC HOUSES

The old Garda Station at the eastern (village) end of Butterfield Avenue has been refurbished in recent years. Nearby is a cluster of old houses, including Butterfield House. Dunfirth House, just beside this house, was built on lands of Butterfield in the 1920s.

Another of the four eighteenth-century houses on Butterfield Avenue is that of Old Orchard, which stands on the left-hand side of Butterfield Avenue leaving Rathfarnham Village, and across the road from Butterfield and Dunfirth Houses. The whitewashed Old

Orchard House still looks resplendent while retaining its rustic appearance after all these years. *Lewis's Dictionary* lists the occupant of Old Orchard House in 1837 as P. Larkin. *Griffith's Valuation* in the 1850s lists a Mr Graham Kennedy.

Past the junction with Butterfield Park are two granite-fronted picturesque old cottages at Nos 182 and 184 Butterfield Avenue. Just beyond the cottages is a relatively new development of red-bricked apartments and houses at Charleville Square. Further along the avenue is another fine detached house with a partial mock Tudor front, and set back from the road, called Green Royd.

THE OLD ORCHARD AND BACCHUS

Beyond these houses is the Old Orchard pub, nearly opposite the Rathfarnham Shopping Centre. This is a very cosy and atmospheric pub, long a favourite with locals and visitors alike. It is a distinctive one-storey structure embraced in ivy, with plaster images of Bacchus (the Roman god of wine and intoxication) adorning the exterior walls. The interior has a very contemporary 'European' styling. The island bar is an unusual feature and provides service around the full 360°, earning it its local nickname of the 'thripp'ny bit'.

WASHINGTON AND EMMET

The next fine detached house we come to is Washington House. Its attractive eighteenth-century facade is hidden by shrubbery, except for the very distinctive large slate roof that extends nearly down to road level. Its exterior from the main road, however, gives some indication of its age, but we have to go down the adjacent Washington Lane to see the historic dwelling. This house, as earlier indicated, has links with George Washington and Robert Emmet. It is Georgian in style and was built in about 1742. One of its notable features is a four-centred carriage arch in the rear wall of one of the outbuildings. It appears on the 1843 Ordnance Survey and is listed in *Thom's Directory* (1854) as being occupied by William Boyle.

The lane itself merits a visit, consisting as it does of a mix of houses from the eighteenth century, including Orchardstown House, now divided into two whitewashed dwellings, yet retaining its antiquity, and dwellings of more recent years. The lane itself has that feeling and atmosphere of a rural idyll, tucked away from the hustle and bustle of the city.

It was in this house that the famous Irish romantic novelist Annie M.P. Smithson (1973–1948) stayed with cousins for several months in 1895. It was on the advice of her doctor that the best-selling novelist moved to Rathfarnham – to avail of the quality of air on Butterfield Avenue. While a nurse and midwife, she wrote seventeen best-selling novels, including *Her Irish Heritage*, *The Marriage of Nurse Harding*, *The Walk of a Queen*, *The Laughter of Sorrow*, *By Strange Paths* and *Leaves of Myrtle*. She was also secretary and organiser of the Irish Nurse's Union and worked tirelessly amongst the poor in the tenements of Dublin. Years later she recounted her time working in Mercer's Hospital, York Street, and a girl she called 'Mary Mercer' who was so fond of cats that she made 'cat holes' in the hospital walls for the convenience of the cats to come and go!

THE MARIAN YEAR

Marian Road, across from the Rathfarnham Shopping Centre, derives its name from having been built around the time of the celebrations in Ireland of the Marian Year of 1954. Passed the shopping centre, Kilvere is a small housing development that was the 1995 winner of the Tidy Districts and also the Environmental Awards overall winner. A narrow entrance at the end of the estate leads to Dodder Valley Park.

W.B. YEATS AND THE TWO RIVERSDALES

There has been much additional housing stock added to Butterfield Avenue in recent years, including the attractive gated community of red-bricked houses and apartments at Charleville Square. Just before the junction of Butterfield Avenue with Ballyroan Road, on the right-hand side, is a very impressive old house called Riversdale. This is a detached, single-storey over basement house, with a handsome double-fronted facade, built around 1850. Set on nearly 2 acres of land, the house, like so many of the surviving villas of Rathfarnham, is of immense character synonymous with its era.

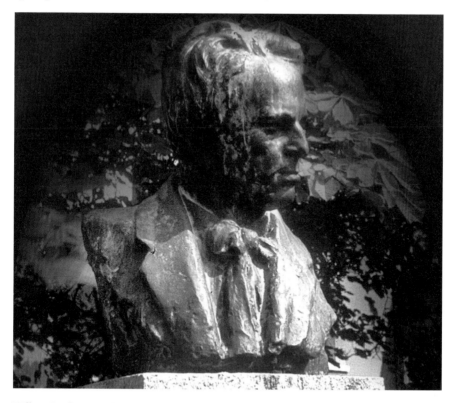

William Butler Yeats (1865–1939), poet and dramatist. He is regarded as the greatest poetical figure of his age. Co-founder of the Irish National Theatre, in 1923 he was awarded the Nobel Prize for Literature. He lived for thirteen years at Riversdale House, Ballyboden Road, Rathfarnham. (Courtesy of the National Library)

Many have confused this as the house where Irish poet, W.B. Yeats lived. However, the poet actually lived at Riversdale on the Ballyboden Road. It is quite understandable for both houses to share the same name, as the one on Butterfield Avenue has the River Dodder sweeping passed its back garden and the Riversdale on Ballyboden Road has the Owendoher River nearby.

THE BLUE HAVEN

Across from Riversdale we have another popular pub, the Blue Haven. It is a popular meeting spot among young and business people alike, situated on the junction of Ballyroan Road and Butterfield Avenue, near Templeogue Bridge (now called Austin Clarke Bridge, in honour of the poet).

THE MILITARY ROAD AND THE SALLY GAP

Rathfarnham is the start of the infamous Military Road (still in use for mainly tourist traffic), one of the most famous roads, historically, in south Dublin. This road, was built at the beginning of the nineteenth century to open up the Dublin and Wicklow Mountains to the British Army to assist them in putting down the insurgents who were hiding there after the Irish Rebellion of 1798. These mountains had for centuries been the bane of the dwellers of the Pale, as the O'Byrne and O'Toole clans made regular incursions, well into the nineteenth century, into the city and caused much havoc and damage.

Construction commenced on 12 August 1800 and was completed in October 1809. The road starts outside the Yellow House on Willbrook Road, passes the head of Glencree, with a spur down that valley to Enniskerry, rises to the Sally Gap and then dips down to Laragh, through the Glendasan Valley, over the hills into Glenmalure, and finishes at Aughavannagh. Well-known sections also include the Featherbed Mountain and the section below Kippure Mountain. The total distance was nearly 40 miles, of which the spur to Enniskerry was 5 miles. The engineer in charge was Alexander Taylor (born in 1746), who was responsible for many other roads in the country, including some 'Turnpike Roads', or Toll Roads. His name lives on in some of the place names of Rathfarnham, most notably Taylor's Lane.

In a letter written in 1809, at the age of 63, he complained of his rheumatism, and those of us who have experience of the climate to be expected in the barren areas traversed by the roadworks that he directed would understand fully where that originated!

DESIRABLE WILLBROOK

Willbrook Road commences beside the Yellow House and passes on the right St Bridget's House, a very impressive villa standing back from the road. The latter is an example of those houses that sprung up in Rathfarnham in the eighteenth and nineteenth centuries when it was seen by the wealthy as a most desirable area to live in. This fine house was described by the historian D'Alton as a 'cruciform edifice

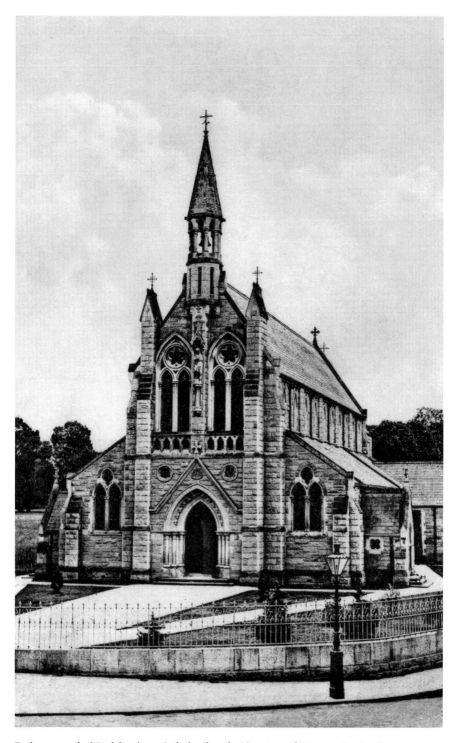

Early postcard of Rathfarnham Catholic church. (Courtesy of Historic Pics Inc./ Rathfarnham Parish)

St Bridget's House, Willbrook Road, 1992. It was built around 1870 by the original owner of the Yellow House pub for his daughter. (Courtesy of Patrick Healy/South Dublin Libraries/McGough Family)

with galleries disproportionately low'. Just beside it, tucked away through gates and between it and the Yellow House, is a very quaint little terrace of houses and cottages in a fairy-tale setting.

One of Rathfarnham's best-known former residents, Dr Joe McGough (RIP 2003) lived with his family in St Bridget's, the gracious Georgian listed house, since 1948. He was a former general manager of An Bórd Bainne, Senior Counsel and retired army lieutenant colonel. In an interview in 2000 with *The Irish Times* he recalled:

Rathfarnham was quaint in 1948, with an old-world atmosphere, just part of the run-up to the mountains. The village was just one narrow street and the shops were long-standing. The Golf Club was on the edge of the village, on Butterfield Lane. You could walk over to the Bottle Tower on The Narrows, a winding stone-walled road built as a 'folly' to give employment. Our house was built by the owner of the pub, which I think is where the church is now. It was on a five acre site and he divided it in two and built St Bridget's to give to his two daughters. The son got the pub.' He continued: 'The Yellow House has connections with Robert Emmet. Michale Dwyer, Ann Devlin's uncle, came down from the mountains and arranged to meet Emmet to harass the Redcoats.' He also noted that 'the artist Sean Keating lived up towards the mountains and William Cosgrave and his family came from Stocking Lane to Mass on Sundays. He sat on one side of the church, his wife on the other and their son would sit at the back.

(*The Irish Times*, 10 February 2000)

A short distance along Willbrook Road, on the right-hand side, is the distinctive granite one-storey building that was the former boys school. It is now the parish's Pastoral Centre. The first entry in the records refers to the establishment of a male school in January 1842. In January 1977, St Mary's Boys National School was opened. From 1978 until the opening of the Courthouse in Tallaght in 2000, the building served as a District Courthouse. In 1978, the Court of Petty Sessions at Main Street, Rathfarnham which was opened in 1912, was then closed. One must note the low ornate entrance doorway with a very distinctive design. Just passed this building is St Mary's, a fine building that is the parish's presbytery. Centuries before, in the time of the Penal Laws, when the practice of Catholicism was banned, there was a Mass House situated close to the banks of the River Owendoher that runs behind the house. Catholics would have to cross the river with some difficulty each time they went to Mass. There was also a high hedge along the Military Road that sheltered the congregation from informants.

Across the road, the fine carved granite pillars of the former entrance to Beaufort House now flank the pedestrian entrance to Beaufort Downs estate. On close inspection of the pillars you can still see the faded words Beaufort College carved on them.

There are fine residences along this stretch of the road with particular architectural features that lend to their uniqueness and attractiveness. The wooden porches are a case in point.

Further along, on the left-hand side and passed the junction, is the main street of Willbrook village. Willbrook Street is a quiet retreat lying between two busy thoroughfares, Whitechurch Road and Ballyboden Road. Near the Tuning Fork pub, it has seen few changes in the last hundred years. Many of the surrounding residences were built about the beginning of the nineteenth century. When one sees

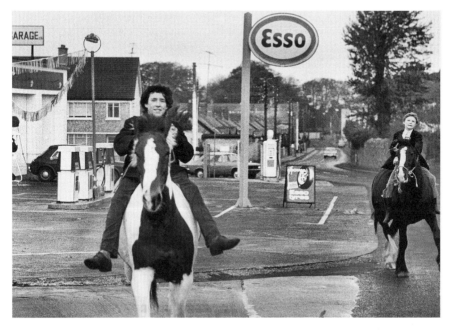

Anthony Maughan and an unidentified boy on horses, Grange Road, Rathfarnham beside petrol station, 1971. (Courtesy of George Gmelch/South Dublin Libraries)

the Owendoher stream nearby, we are reminded of the many mills that populated this area for generations. The Irish version of Willbrook is in fact '*muileann*' – 'mill'. So, the place names should be Millbrook rather than Willbrook! There is an open green area here called Willbrook Park, which reinforces the village feel to the area.

At this junction, on the right of the fork, Willbrook Road ends and Ballyboden Road begins, and Whitechurch Road continues towards the Dublin Mountains along by the walls of St Enda's and Marlay Parks.

THE LAST HOME OF W.B. YEATS IN IRELAND

Across the road from Willbrook village we see the name Fairbrook House on entrance pillars to a small housing enclave. This fine house is no more as it was demolished in the late twentieth century and the land used for housing. An important house that was not demolished, however, is Riversdale House, further along the Ballyboden Road at a turning for Boden Wood. This was the last residence in Ireland of the poet W.B. Yeats (1865–1939), where he resided for thirteen years. Yeats is regarded as the greatest poetical figure of his age. Co-founder of the Irish National

A tub trap in Rathfarnham, 1971. (Courtesy of George Gmelch Collection/South Dublin Libraries)

Theatre (the Abbey Theatre), in 1923 he was awarded the Nobel Prize for Literature. Yeats took a thirteen-year lease of Riversdale House in 1932 and he lived there with his wife, George and his two children, Anne and Michael. In 1938, Yeats met Maud Gonne in the house for the very last time, a woman who inspired some of Yeat's greatest works. Two of his poems are about Riversdale – 'What Then?' and 'An Acre of Grass'. In the former poem, published in 1938, he wrote about Riversdale:

> All his happier dreams came true –
> A small old house, wife, daughter, son,
> Grounds where plum and cabbage grew,
> Poets and Wits about him drew;
> 'What then? sang Plato's ghost,
> 'What then?'

Near Riversdale is an old wall plaque across the road from some ornate cottages. The sign states that we are 5 miles from the GPO.

There are a number of other old detached dwellings, called 'villas' in the nineteenth century, along the Ballyboden Road, including Rosebank House, Edenbrook House and Ballyroan Lodge. The name Bolton Hall is barely visible on the entrance to what is now a housing/apartment complex at the junction of Ballyboden Road and Ballyroan Road. These villa residences, also a feature of Butterfield Avenue and other parts of Rathfarnham, were chiefly occupied by the higher professional and mercantile classes of Dublin.

THE BUGLERS

Turning right at the Tuning Fork pub on the Ballyboden Road to the Taylor's Lane/Ballyroan Road junction we pass many interesting dwellings, including well-preserved cottages, new housing developments, and all the while we hear the sound of the Owendoher and other streams bubbling along, parallel to the road. The inviting Buglers pub is situated along the Ballyboden Road. John Blake was the first known publican to be granted the licence in 1799.

Turning left onto Taylor's Lane we see the low building of Whitechurch Library. This is a part-time former Carnegie Library that opened in 1911 and has been in use since then. It is still in its original condition. Nearly adjacent to the library, we come across an oasis of tranquility in a beautiful rural-like setting – the Augustinians retreat centre, also well-worth a visit.

FOUNDING MEMBER OF GAELIC LEAGUE

Going beyond the junction with Taylor's Lane and travelling towards Stocking Lane and the Hell Fire Club is an area called Woodtown. This is where an important figure in early twentieth-century Irish revolutionary history lived for many years. Eoin MacNeill (1867–1945), was a founder member of the Gaelic League in 1893 of which he was vice-president. He founded the Feis Cheoil the following year. He was appointed the first Professor of Early (including Medieval) Irish History in UCD in 1908, a position he held until 1941. Commander-in-Chief of the Irish Volunteers,

he was unaware of the planning for the Easter Rising and on the Sunday morning he issued an order countermanding the mobilisation. The 1916 Rising went ahead despite this. Arrested and sentenced to life imprisonment, he was released in the general amnesty of 1917. He was Minister for Education in the Executive Council of the Irish Free State, 1922–25. He was appointed Free State representative on the Boundary Commission on its foundation in 1924.

THE TUNING FORK AND THE WINDING ROAD TO WHITECHURCH

Returning to the Tuning Fork junction, we take the left road, Whitechurch Road. The Tuning Fork was an old-style pub situated at the junction of Willbrook Road and Whitechurch Road, near the Yellow House pub. It is now closed. It derived its name from its position at the junction of two major roads leaving Rathfarnham.

The Whitechurch Road branches to the east of the Tuning Fork pub and follows the course of a little river which flows down from Kilmashogue Mountain. On the left side of the road is a partly choked-up mill race which was taken from the river higher up to serve the Silveracre Mill. This was named Brooklawn Mill on both Taylor's map

Mill House, Whitechurch Road, Rathfarnham. (Courtesy of Dublin History)

of 1816 and on Duncan's of 1821. In 1836 Mark Flower had a pin and wire factory here which was then named Silveracres Mill. This closed down in 1853. The place was then converted into a flour mill by Robert Gibney who also owned the nearby Willbrook Mills. From 1864 to 1893 it was operated by Patrick Gibney, after which it was taken over by Mr J.E. Madden. Subsequent to 1899 it changed hands frequently and the last tenant was Mr Murray, from 1922 to 1933. The mill has since been demolished but the name Mill House still remains. Likewise, Silveracre House still stands at the beginning of the road, reminiscent of different times.

Bulmer Hobson (1883–1969), Irish revolutionary and writer, lived at Mill House. After the establishment of the Free State in 1922, he was appointed chief of the Revenue Commissioners Stamp Department. Among his publications were *The Life of Wolfe Tone* (1919), *A National Forestry Policy* (1923), and his landmark work, *Ireland Yesterday and Tomorrow* (1968).

TOWARDS COFFEE HILL

Follow this road along by the walls of Marlay Park and St Enda's Park, past the Grange (opened in 1910) and Edmondstown Golf Courses and on in the direction of

Labourers' plots behind cottages in Rathfarnham in the mid-twentieth century.
(Courtesy of John Byrne/South Dublin Libraries)

Tibradden and St Columba's College. Along the way, we have Anne Devlin and Sarah Curran roads that lead back to Grange Road. A turn left before the flyover bridge near St Columba's College will bring us back along Marlay Park wall and returning to Rathfarnham via College and Grange Roads. Continuing on passed the college brings us to the steep slopes of Tibradden.

Along the winding way, the scenery very pleasant, we pass the Moravian Cemetery. Just passed Grange Golf Club entrance is a long row of mostly detached granite-fronted cottages with extensive back gardens. These are particularly picturesque and well-kept and were once known as 'Coffee Hill' but now as just 'The Cottages'. Further along we come to the steep entrance to the Church of Ireland Whitechurch parish church that is well-positioned on a hill with a commanding view of the surrounding area. It has a very unusual narrow entrance doorway. Here we will also find the final resting place of one of Ireland's most popular novelist in the early to mid-twentieth century – Annie M.P. Smithson.

5

HISTORIC
MONUMENTS

KILMASHOGUE HILL WEDGE TOMB

Rathfarnham is very lucky to have so many historical monuments, some of them in the nearby Dublin Mountains.

On the peak of Kilmashogue Hill, there lie several megalithic tombs. It is believed the tombs date back to around 2000 BC. The megalithic tombs consist of massive rock slabs and one may just wonder at how they actually transported them and lifted them into place. Clay pots and bones were some of the artefacts discovered when the tombs were excavated. The roofless gallery is triple-walled and the very high

Mount Venus cromlech in the Dublin Mountains. (Courtesy of Dublin.ie Forums)

sill-stone between the antechamber and the main chamber is a very unusual feature. The wide, rectangular chamber still has a huge entrance stone in place and there is a surrounding bank and ditch that can still be very clearly seen.

A possible reason why these the tombs were built on the top of Kilmashoge is that from the top you have a magnificent view over Dublin Bay – perfect for spotting unwelcome visitors. In fact, today one may still enjoy some of the best views of Dublin City from many vantage points just beyond Rathfarnham, as one ascends the hills.

MOUNT VENUS – THE MAGNIFICENT DOLMEN

This national monument is situated on Mount Venus Road. Often referred to as the 'Mount Venus Dolmen' or as the 'cromlech', it has been described as one of the most magnificent in the world. It encompasses a massive cap stone weighing in at 44 tons. The giant stone measures 6m in length, 3m in width and 1.9m in depth, and has slipped off portal stones, of which one remains standing. It is near Mount Venus Cemetery, located on lands belonging to DSPCA, on the Mount Venus Road.

TIBRADDEN – GRAVES AND RUBY TOUGH

On the peak of this mountain, beyond Rockbrook, there is a prehistoric passage grave with a long narrow entrance to a circular chamber. When the original cairn was excavated in 1849 by the Royal Irish Academy it contained a burial urn and food vessel (now in the National Museum). Today, we can also see an elaborate surrounding structure: a circular, roofless, dry-walled chamber, almost 3m in diameter. However, there is a question as to whether this outer, seemingly more recent structure, is in fact a 'folly', using stone from the cairn.

An interesting fact about Tibradden Mountain is that it features in Samuel Beckett's story called 'Love and Lethe', a humorous drama. It tells the tale of Beckett's anti-hero, Belacqua, a philandering Dublin student, who takes his girlfriend, Ruby Tough, to the top of Tibradden with the intention of carrying out a suicide pact with her. In the end, it fails and turns into the 'inevitable nuptial'.

THE BREHON'S CHAIR – A NATIONAL HERITAGE MONUMENT

In the grounds of Glensouthwell, across the road from Taylors Three Rock Pub, you can find an unusual monument: three 3m granite stones closely huddled together in the shape of a chair. The Brehon's Chair is believed to have been the seat of Judgement of the Arch Druid, from which judgements from the Brehon Law, which governed Ireland in the period prior to the Norman invasion of the late twelfth century, would be passed. When the settlement around the chair was excavated, flint tools were among the artefacts found there. Further excavation showed that it was originally a megalithic passage tomb dating from 500 BC to 2000 BC. This is now a national heritage monument and would originally have been surrounded by the Glensouthwell demesne, but the expansion of Rathfarnham saw it become a showpiece in a housing development.

THE HELL FIRE CLUB

Overlooking Dublin city from the south west, in the area of Killakee Woods, and at an altitude of 383m (1264ft), is a foreboding ruined hunting lodge. Current lore insists on telling us that it was – and still is – a site commonly used for the practice of 'Satanism' and other occult activities, and that the Devil himself made a brief appearance there at some unspecified time in the past. In one such story, a mysterious stranger seeks shelter on a stormy night, and a card game ensues. A member of the household drops a card and sees that, below the table, the otherwise affable and charming visitor has a cloven hoof. His or her screams made the Devil 'aware of her discovery, and he at once vanished in a thunder-clap leaving a brimstone smell behind him'.

Weston St John Joyce mentions Montpelier in his *The Neighbourhood of Dublin*, published in 1912:

> Making our way over the gorse and heather up the slopes of the hill from Mont Pelier House, we at length come into view of the old ruin on the top – an interesting and conspicuous object from afar, but proving a most unprepossessing structure on closer acquaintance. It is variously known to the Dublin folk as the Hell-Fire Club House, the Haunted House, and the Shooting Lodge, although it really possesses no valid claim to any of these designations, it having been built, apparently as a mere freak, for use as an occasional summer residence, by the Right Honourable William Connolly of Castletown, Speaker of the Irish House of Commons, about the year 1725, shortly after he purchased the Duke of Wharton's estate in this neighbourhood.

St John Joyce mentions another satanic appearance, due to the use of part of a local megalithic standing stone in the construction of the lodge:

> Shortly after the house was built, the slated roof was blown off one night in a tremendous storm – by the agency of the devil it was popularly believed, on account of the sacrilegious conduct of the builder in desecrating the old carn. But Squire Connolly was not a man to be easily beaten, and so he set to work and built a massive arched roof of stones keyed together as in a bridge, and of such impregnable strength that it has effectually withstood the efforts of wind or devil – whichever it was – from that day to this.

St John Joyce also expressed uncertainty with regard to the tenuous occult significance of Montpelier:

> With regard to one of the names which seems to have taken the fancy of the public, it is to be observed that while the Hell Fire Club may have held some of its meetings in this house, it is tolerably certain that it was never one of the regular meeting-places of that mysterious and iniquitous body, the ordinary rendezvous of which was the Eagle Tavern on Cork Hill.

Besides the Hell Fire Club itself, there is also an ancient cairn nearby. There are a number of ways to access the club, either straight up the steep, rock-strewn hill, from the car park, or the more circular, easier but longer route, also starting from the car park.

Grange Road, Rathfarnham. Cast-iron vent pipe, dated 1912, with bulbous base and plain slender shaft. It bears the inscriptions 'SD RDC' and '1912'. (Courtesy of South Dublin Libraries)

6

THE MILLS OF RATHFARNHAM

STEAM ENGINES AND THE END OF AN ERA

Because of the abundance of water from the Dodder and Owendoher Rivers it is not surprising that Rathfarnham was the site of many mills over the centuries.

In the eighteenth century many paper mills were erected on the Owendoher and Dodder rivers. In the beginning of the nineteenth century most of them switched to cotton and wool and later to flour mills. The introduction of steam engines marked the end of this era and replaced the need for mills. Many of the old buildings fell into disrepair and were demolished, and their mill races filled in.

A millpond and extensive mill buildings formerly occupied the low-lying fields on the west side of the main Rathfarnham Road, just beside the bridge. In the grounds of Rathfarnham Castle were several fish ponds which were supplied by a mill race taken from the stream which rises up at Kilmashogue and flows down through Grange Golf Links and St Enda's Park. This served several mills before entering the fish ponds, and from here it ran through the nearby golf links while a smaller branch was conducted under the road to the flour mills which stood at the corner of Butterfield Lane. Described in 1836 as Sweetman's Flour Mills, it frequently changed hands before closing down in 1887. It was later operated as a saw mill.

WOODVIEW'S OLD PAPER MILL

Church Lane at the side of the bank on the village's main street leads down the hill to Woodview Cottages, which are built partly on the site of an old paper mill. The mill race previously mentioned passed under Butterfield Lane to the paper mill and continued on below Ashfield to turn the wheel of the Ely Cloth Factory. Today, the only reminder of the mill is the name Rathfarnham Mill on the apartment/ housing complex next to Woodview Cottages.

SILVERACRE AND MILLHOUSE

At Willbrook the Whitechurch road branches to the east and follows the course of a little river, the Owendoher, which flows down from Kilmashogue Mountain. On the other side of the road is a partly choked up mill race which was taken from the river higher up to serve the Silveracre Mill. This was named Brooklawn Mill on Taylor's map of 1816 and on Duncan's of 1821. The dwelling, Millhouse, survives today as a reminder of the activities in the area long ago. In 1836 Mark Flower had a pin and wire factory here which was then named Silveracres Mill. This closed down in 1853.

St Gatien's, on the other side of the road occupies the site of Willbrook Flour Mills already mentioned. This was Egan's Flour Mills, noted by D'Alton in 1836.

Newbrook Mill was on Taylor's Lane where extensive paper manufacturing was carried on for many years.

MILLBROOK MILLS

Opposite Orchardstown Estate, with a waterwheel 16ft in diameter, stood Millbrook Mills, otherwise known as the Little Mill. At the northern end of Ballyboden was a woollen cloth mill which belonged to John Reid from at least as far back as 1836, when D'Alton, in his history of County Dublin, stated that this mill gave employment to about forty people. Within a stone's throw of Reid's Mill and behind Bolton Hall was a paper mill belonging to Nicholas Ryan which is shown on the map of 1837.

A LINE OF MILLS AND INK AND DYE

According to local historian Patrick Healy, more than a hundred years ago there was a continuous line of mill ponds as far as Rockbrook. First on the left was Sherlock's Cotton Mill, which was converted into a laundry in 1873 and closed down before 1920. Next, beside the row of mill workers' cottages, was a paper mill operated by Messrs Dollards from 1848 to 1896. It was later run by the Edmonstown Paper Co. until about 1912. Reckitt's well-known ink and dye factory was on the site of another woollen mill which was also operated by John Reid of Ballyboden until 1892 and by Frederick Clayton & Sons until 1900. The dye factory closed down in the late twentieth century, but the name was still over the entrance for many years afterwards.

On the other side of the river the school is built on the site of Newtown Great Paper Mill. A short distance further up are the remains of Millmount Mill run by Messrs Dollards who operated it in conjunction with their paper mill lower down the river. Here the rags were processed and made into the raw material from which the paper was manufactured. This mill closed down in 1899.

Today, the only reminders of this age of mills are in the Irish version of place names, in particular, Willbrook Road (Irish place name: *muileann* = mill) and Millhouse on Whitechurch Road.

7

STEEPLES AND CHURCHES

DRACULA AND THE CHURCH OF IRELAND IN RATHFARNHAM VILLAGE

There is no doubt that the steeple of Rathfarnham Church of Ireland church is a highly-visible and noteworthy landmark that stands out not only in its wider surroundings but also amongst some of the mediocre developments that have swamped the village itself in recent years.

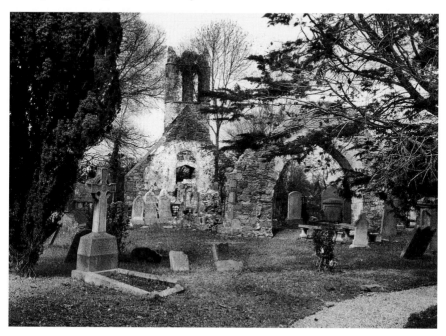

Rathfarnham Graveyard. (Courtesy of OPW/DCC)

Group praying at St Columcille's Well, Ballycullen, Rathfarnham, 1954. (Courtesy of National Library of Ireland)

History records a timber parish church in Rathfarnham at 1212. Later a stone church was built on the site the ruins of which remain today, in the old graveyard north of the present church. In 1779/80 a decision was made to build a new church as the congregation grew in numbers. In 1785 the foundation stone for the new church was laid on the present site and in 1789 it opened for worship. The church was consecrated in 1795.

One enters the church grounds via a cast-iron gate. One's attention is drawn to a beautiful yew tree on the approach to the church entrance itself. The church has a richly decorated interior. Entering the fine church through the doorway under the spire, a simple staircase rises to the organ loft; the entrance to the church is to the visitor's left. The interior is surprisingly big with a large organ dominating the right-hand transept. Besides the stained-glass windows, the ornate structure both inside and outside, and its landmark steeple, some of the wall plaques are of interest, including one to Abraham Stoker, the father of Bram Stoker, author of *Dracula*. The plaque celebrates his fifty years in the Irish Civil Service.

Beside the church is the old school house that dates from early in the nineteenth century. The attractive vicarage is on Main Street, opposite the court.

THE BEAUTIFUL AND THE GOTHIC – THE CHURCH OF THE ANNUNCIATION

The Catholic Church of the Annunciation was designed in early French Gothic style with the nave, aisles and chancel terminating in three semicircular apses. The architect was G.C. Ashlin. The foundation stone of this large and handsome edifice, that is capable of holding a congregation of nearly 1,000, was laid on 29 March 1875, and the church dedicated 27 March 1878 by His Eminence Cardinal McCabe. It was described at the time by the renowned Dominican preacher Fr Thomas Burke that it was to be built, 'as a palace to Jesus Christ'. It was erected to replace the old chapel in Willbrook Road.

The *Freeman's Journal* at the time noted that, 'for skill in design and artistic workmanship, the church would compare favourably with, if not surpass any in or near Dublin ...'. It went on to describe the 'whiteness of the cunningly carved marble of the altar and tabernacle' and 'the altar is a beautiful achievement in marble and Caen stone, the communion rails are of Italian marble, massive

Praying at St Columcille's Well, Ballycullen, Rathfarnham, 1954. (Courtesy of National Library of Ireland)

columns of Aberdeen granite separate the aisles'. Moreover, 'the sun borrowed varied tints from the coloured windows through which it shone, and gave a needed warmth to the masses of marble and stone'. Finally, 'to so much inanimate beauty was added the golden robes of the bishop who presided, the white and black of the friars, the lights of the altar, the perfume of the incense, the music of the choir, collectively formed the splendid ceremonial' for the dedication of the church.

This striking early Gothic Revival church retains many fine internal and external features. It was described by a visitor in 1912 as being 'one of the most ornate and beautiful parish churches in the kingdom'. The pointed arched windows and granite external walls are a strong feature. The several beautiful stained-glass windows and ornate plasterwork inside give much to ponder and wonder. In fact, the most unusual feature of the church are these windows as they incorporate the Stations of the Cross. They are the work of Maison Eugene Denis of Nantes and date from the late nineteenth/early twentieth century. The colours are bright and quite strong compared with the older glass in the side of the chapel windows. Prominently sited at a junction, the church is a focal building both physically and socially. Outside the church door is an old-style type of holy water font on a pedestal bearing the inscription:

FONT USED IN MASS HOUSE OF PENAL TIMES IN PARISH OF RATHFARNHAM FROM 1732.

THE ROMANCE OF WHITECHURCH PARISH CHURCH

Whitechurch parish is an interesting 'country' church. Its roots can be traced back to the twelfth century, when it was under the oversight of St Mary's Abbey, Tallaght. Today, the ruins of the old Whitechurch stand about half a mile down the road from the present church and where two decorated and very rare slab crosses are found, probably dating from the tenth or eleventh century.

In 1823, Whitechurch National School was established in the grounds of the present church. In 1827, a new church (the present church), officially titled 'New Whitechurch', was consecrated, blessed and opened for public worship by William Magee, Archbishop of Dublin. The church's architect was John Semple, the architect of several Dublin churches and also of the Round Room in the Mansion House, for the official visit of King George IV to Ireland in 1824. The most notable features of Whitechurch – its slender graceful, distinctive spire, the tall, thin lancet windows and very large internal thrust arches – are typical of Semple's work. In succeeding years, a gallery (1834), a funeral door and chancel (1868) and a Vestry Room (1876) were added to the church.

The church's stained-glass windows include three windows linked to Bible incidents concerning angels. One of these windows is the work of Joshua Clarke, the father of Harry Clarke.

There are two organs in the church, both dating from the later end of the nineteenth century. The original organ, a two-manual, tracker-action Browne (Dublin) pipe organ, remains in place and in periodic use. In 1993, due to increasing liturgical demands, the two-manual Connacher (Huddersfield) organ from the redundant St Mary's Church, Ballinrobe, County Mayo, was transported, restored and rebuilt in Whitechurch, on a now extended gallery. A key figure in this whole

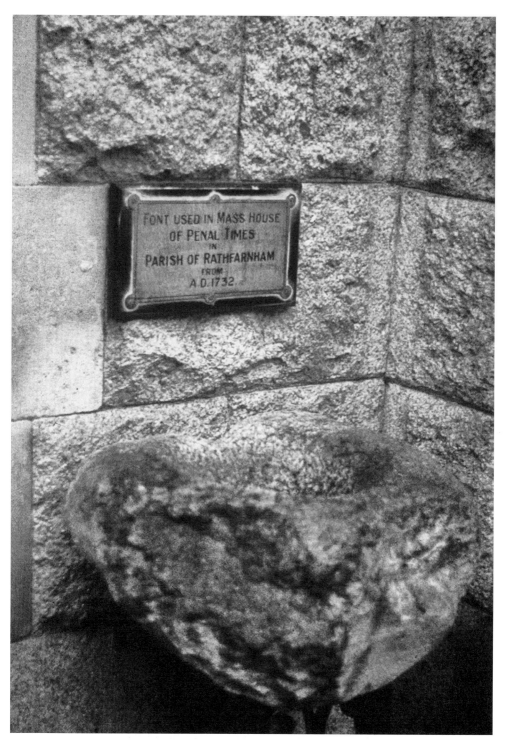

Penal water font at entrance to Rathfarnham Catholic Church of the Annunciation. (Courtesy of Patrick Healy/South Dublin Libraries/Rathfarnham Parish/Tony Corcoran)

Two men in conversation at St Columcille's Well, Ballycullen, Rathfarnham, 1954.
(Courtesy of National Library of Ireland)

project was the parish organist of the time, Stephen Adams, who is himself a noted organ builder by profession.

Whitechurch cemetery, in the grounds of the very picturesque church is the burial place of Annie M.P. Smithson. She was one of Ireland's most popular romantic novelists in the first half of the twentieth century. Besides living at Washington Lane for a short time, she was also the district nurse in Rathfarnham for a number of years.

ONE OF IRELAND'S GREATEST PAINTERS AND BALLYROAN CHURCH

The Catholic parish of Ballyroan was constituted from Rathfarnham parish. The parish church was dedicated to the Holy Spirit and was blessed and opened by the then Archbishop of Dublin, Dr John Charles McQuaid, on Sunday 3 December 1967. It was designed by Raymond McDonnell with decorative work by Imogen Stuart.

Ballyroan townland is surrounded by Old Orchard, Butterfield, Knocklyon, Scholarstown and Ballyboden townlands. The modern townland of Ballyroan consists of major portions of the lands of Sancta Maria College, St Patrick's National School, Mercy Convent, Ballyroan House and major portions of the following housing estates – Ashtown Lawn, Close and Grove, Ballyroan Heights, Elkwood, Hillside Park and Templeroan Estate (excluding the major portion of Templeroan Green and a small portion of Templeroan Court). The long and attractive

Men saying the Rosary, St Columcille's Well, Ballycullen, Rathfarnham, 1954. (Courtesy of National Library of Ireland)

Ballyroan Road marks the boundary (questionable!) between Rathfarnham and Firhouse and links Templeogue Bridge (Austin Clarke) to the Ballyboden Road.

Besides being a particularly beautiful church, with fine stained-glass windows, it is also the home of two of the great Irish painter Sean Keating's pictures, and well worth a visit. His paintings are positioned high up on the left and right-hand walls as you approach the altar.

Sean Keating (1889–1977), lived in Ballyboden, where he had a house built on the site of Millbrook Mills in 1935. One of his most iconic works is 'Men of the South', which depicts an IRA Flying Column poised ready to attack. He was elected to the Royal Hibernian Academy in 1923 and was president from 1949 to 1962.

Next door to the church is a particularly fine Dublin County Council public library. It was the recipient of the 2013 Irish Architecture Awards for 'Best Public Building' in Ireland.

8

WOODS, PARKS AND PONDS

PARK AND WALK: THE MANY PARKS OF RATHFARNHAM

Rathfarnham is extraordinarily blessed with fine parks. Marlay, St Enda's, Bushy, Dodder Valley, Loreto Park (Nutgrove) and Rathfarnham Castle Park, which add recreational opportunities, colour and sheer variety and much, much more to this unique area. The Dodder Valley runs parallel to the River Dodder and when one crosses some of the footbridges, one enters Bushy Park. St Enda's and Marlay Park, with entrances on Grange Road, Whitechurch Road and Taylor's Lane, must be two of the most attractive parks in Dublin. It may be truthfully said, that some of Dublin's most charming and atmospheric parks, with riverside walks, waterfalls, walled gardens, woods, recreational facilities etc., are to be found in Rathfarnham.

MARLAY PARK – THE JEWEL IN THE CROWN!

Marlay Park is a 121 hectares (300 acres) public park located in Rathfarnham between Grange Road, Taylor's Lane and Whitechurch Road. The beautiful parkland, with its stunning and uninterrupted views of the distant Dublin Mountains, comprises mature woodlands, extensive informal lawns, a wall garden, ponds, streams, walks and acres of recreational land. With the perfect backdrop of the Dublin Mountains, this park, particularly the area close to Marlay House, must be one of the most picturesque parks in the country!

There are many hidden gems in Marlay, including a small bridge over the stream that winds its way through the woods. An interesting feature of the bridge is the harp sculpted over the arch. This and much more, will captivate the walker.

Recreational spaces include a nine-hole par-three golf course (reopened in 2010 after redesign and rebuild), tennis courts, six football pitches, five GAA pitches, a cricket pitch, two children's playgrounds and a miniature railway run by the Dublin Society of Model and Experimental Engineers. There is also a craft courtyard with homecraft shops and coffee shops and a farmers' market is a regular feature here.

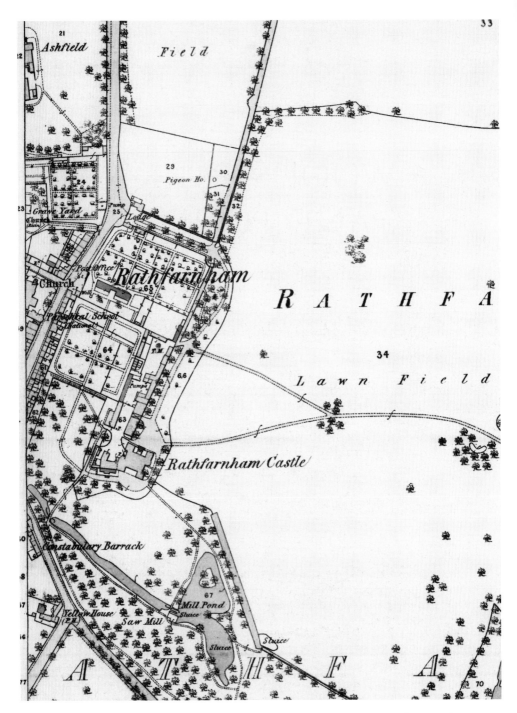

Portion of the parish of Rathfarnham, comprised of sheets XII.6 and XII.7. Surveyed in 1864 by Captain Martin R.E. and zincographed in 1865 under the direction of Captain Wilkinson R.E. at the Ordnance Survey Office, Phoenix Park. (Courtesy of South Dublin Libraries)

Postcard of the Pine Forest, Rathfarnham, in the early twentieth century. (Courtesy of Dublin.ie Forums/Damntheweather)

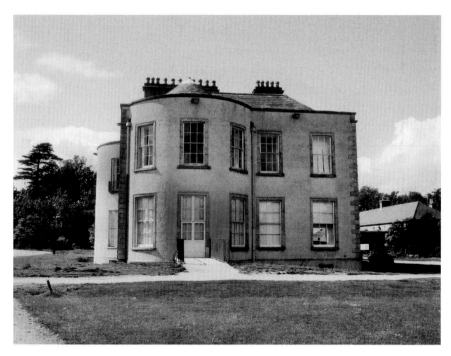

Side view of Marlay House, Marlay Park, R, 2001, prior to refurbishment. (Courtesy of Michael Fewer/South Dublin Libraries/OPW)

The Priory, opposite Marlay Park, before it was demolished. (Courtesy of the National Library of Ireland/Come here to me)

Bridge with harp detail in Marlay Park, located adjacent to one of the popular walking routes on College Road side of Park. (Courtesy of Dublin Parks/OPW)

Dublin County Council acquired the land in 1972 and developed it as a regional park. Opened in 1975, it is now administered by Dún Laoghaire-Rathdown County Council. Dublin Bus serves the park directly with the No. 16 bus. Since 2000, Marlay Park has become a popular music venue with a capacity of 32,000, featuring renowned national and international performers. The park's name is commonly misspelled as Marley, most notably in nearby housing developments.

MARLAY HOUSE: ELIZABETH AND EVIE

Marlay House was built by Thomas Taylor (note the nearby Taylor's Lane) and was known as 'The Grange'. The Huguenot, David La Touche, first governor of the newly established Bank of Ireland, acquired and extended the house in 1764 and renamed it for his wife Elizabeth Marlay, daughter of George Marlay, Bishop of Dromore. The house, a fine example of Georgian architecture, has many elaborate features including plasterwork by Michael Stapleton. Marlay was sold in 1864 to Robert Tedcastle, a well-known Dublin coal merchant, whose family lived there until 1925 when Philip Love bought the house for £8,325. Love, a market gardener who was once Ireland's largest tomato producers, was also a racehorse breeder whose famous horse Larkspur won the 1962 Epsom Derby. He lived there until 1972, when it was donated to the Dublin County Council.

A 1.82 hectare (4.5 acre) walled garden was built near the house around 1794, and consists of a restored regency ornamental and kitchen gardens. The ornamental garden boasts an extensive display of period plants, ranging from herbaceous

borders to shrub beds. The Head Gardener's house, orangery, arbour and water features combine to create a distinctive atmosphere. Located just over the wall, the kitchen garden houses a fine collection of regency fruit trees, vegetables and associated bothys.

A number of small craft workshops are located in the courtyard adjacent to Marlay House including weaving, glass cutting, bookbinding, furniture restoration, copper craft, pottery, jewellery and embroidery. One of these was originally the residence of the renowned stained-glass artist Evie Hone (1894–1955), whose stained-glass workshop was located in the library of Marlay House itself. She was an outstanding painter of religious subjects. One of her windows 'My Four Green Fields' (1938–39) was commissioned by the Irish Government and was exhibited in the Irish Pavilion at the World Fair in New York. Considered to be one of her most important works, it is now to be seen in Government Buildings on Upper Merrion Street in Dublin. She lived at the Dower House in Rathfarnham and is buried in St Maelruain's Churchyard in Tallaght. There is a plaque on a wall in the Marlay Craft Centre commemorating that she lived there at one time.

THE WICKLOW WAY

Marlay Park is also the official starting point of the 132km Wicklow Way, an Irish long-distance walking trail, that begins at the car park adjacent to Marlay House. The trail wanders through the delightful sylvan surroundings of the park, before tunnelling under the M50 motorway to begin its first ascent southwards towards the Dublin hills and the first of several forest vistas on its way southward over the Wicklow Mountains to Clonegal, County Carlow. The Wicklow Way website estimates that walkers should allow seven hours for the first 21km section to Knockree.

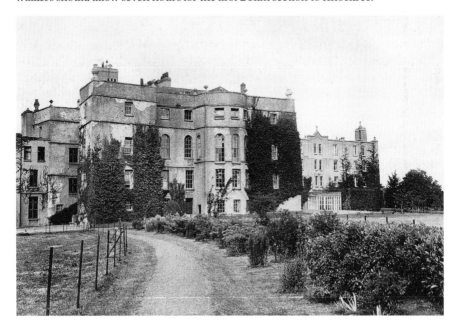

Rathfarnham Castle in the 1950s. (Courtesy of MC's Fotofinish/OPW)

MARLEY GRANGE

Marley Grange (there is also a detached residence opposite The Eden, called Marlay Grange), built in the 1970s, is one of several housing developments adjacent to Marlay Park and contains six roads named 'Marley': Avenue, Drive, Walk, Close, Grove and Wood. Residents assume that the developer misspelled the name when naming the roads.

ST ENDA'S PARK AND THE PEARSE MUSEUM

The nearby St Enda's was not always a public park. St Enda's was the former home and school of 1916 Rising leader, Patrick Pearse and lately of his sister Miss Margaret Pearse. Pearse, one of the leaders of the Easter Rising in 1916, ran St Enda's School (or Scoil Éanna in Irish) in The Hermitage. This magnificent house was built in 1780 for the Dublin dentist Edward Hudson. Pearse, who was a teacher at the time, bought the building in 1910 as his school at Cullenswood House in Ranelagh was getting too small. Pearse felt that the confined surroundings of this house gave no scope for the outdoor life that should play so large a part in the education of youth, so, in 1910, he leased The Hermitage from Woodburn and moved his college here. For Pearse, The Hermitage would allow his pupils a greater experience of the 'outdoor life, that intercourse with the wild things of the woods and wastes, that daily adventure face to face with elemental life and nature'. A long billiard room was converted into a study

Mid-twentieth-century image of the entrance to the Hermitage/St Enda's, Grange Road, Rathfarnham. It was here that 1916 Rising leader Patrick Pearse had his bi-lingual school Scoil Eanna/St Enda's. (Courtesy of Patrick Healy/The Pearse Museum/OPW)

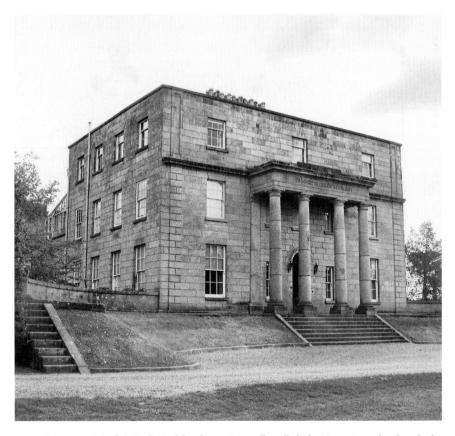

Pearse Museum, St Enda's Park, Rathfarnham. Originally called The Hermitage, this detached three-bay three-storey over basement former country house, built around 1780, is now in use as a museum and visitor centre. A considerable number of follies were built in the gardens. After a succession of owners and tenants, it finally became the home for Patrick Pearse's St Enda's, a boys secondary school. (Courtesy of the Pearse Museum/OPW)

hall and chapel, the drawing room became a dormitory and the stables opening off an enclosed square became classrooms. In 'The Story of a Success', Pearse tells of the realisation of one of his life's ambitions and it was from here that he set off for the city on his bicycle for the last time on Easter Sunday 1916. After the Rising the college continued to be the home of the Pearse family and the school functioned under the care of Miss Margaret Pearse until it finally closed down in 1935.

Prior to the death of Miss Pearse in 1968 St Enda's was handed over to the Irish State with her wish that it be preserved as a memorial to her brothers, and it has since been opened as a public park and is also the home of the Pearse Museum dedicated to the memory of Patrick Pearse, the Pearse family, and their school, and is open to the public all year round. The museum features articles and history about the school and the Rising. Every Sunday, from June to August, there is music entertainment in the courtyard (beside the Pearse Building). The park itself is very attractive with ponds, a river, woods, a museum, a garden, unusual monuments, walks, playing pitches and much else.

Interior decoration in Rathfarnham Castle, 1976. (Courtesy of Davison & Associates Ltd/ South Dublin Libraries/OPW)

THE FIELDS OF ODEN

The house, which is entirely faced with cut granite and has an imposing stone portico, was originally occupied in the late eighteenth century by Edward Hudson. He had a passion for Irish antiquities which he demonstrated in an unusual way by the erection of a number of romantic ruins around the estate. Inside the boundary wall of St Enda's Park, near the entrance gate, he built a small watch (stair) tower and, further along, a hermit's cave, a dolmen, an obelisk, a ruined abbey and, beside a deep well, a tiny chamber with stone bench and narrow fireplace. At the corner of the road to Whitechurch the loopholed and crenellated structure known as the Fortification, or Emmet's Fort was another of his creations. Legend has it that he allowed the revolutionary Robert Emmet and his girlfriend Sarah Curran to meet secretly in the grounds. South of the house he put up a grotto surmounted by a tall pillar stone, a Brehon's Chair (now near Taylor's Three Rock Pub) and a fanciful construction consisting of two great boulders, one balanced on top of the other, which has since been demolished. Just inside the boundary wall he cut an inscription in Ogham on the two faces of a large rock. When the letters are translated they refer to the name Edward Hudson. He also erected a sort of temple with several small chambers and flights of steps. All these features are still in the park, as well as the Druid's Glen, a walled garden, a lake, a summerhouse, playing fields, and the Pearse Museum.

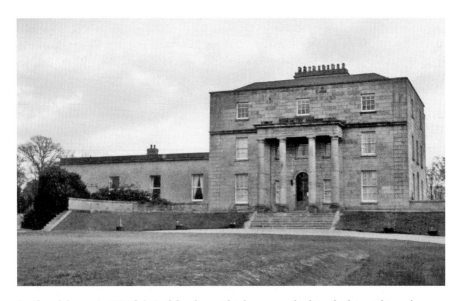

Landmark house in St Enda's Rathfarnham. This house was built in the late eighteenth century with the name of The Hermitage. After a succession of owners and tenants, it became the home for Pádraig Pearse's St Enda's, a boys' secondary school with a focus on the Irish language, mythology and outdoors. (Courtesy of OPW)

The estate was known as the 'Fields of Oden' in Hudson's time and is so called on maps of the period. Within the grounds, at the corner nearest to Whitechurch, is an obelisk, stated to have been erected by a former owner, Major Doyne, over the grave of a horse that carried him through the Battle of Waterloo. The date, however, of Major Doyne's occupation does not support this. Unlike the constructions of Edward Hudson, which were purposely of the roughest material, this monument was of cut stone with small moulded pillars. Unfortunately, the heavy hand of the vandal descended on it, toppled it from its base and smashed the supporting pillars. It has since been re-erected, leaving out the pillars.

Thomas MacDonagh, one of the 1916 Rising leaders, who taught at St Enda's School. (Courtesy of National Archives)

Hudson was succeeded by his son, William Elliot Hudson, who was born here in 1796. A distinguished scholar, he was a friend of the Young Irelanders, Thomas Davis and Gavin Duffy, and was a patron of Irish literature and art. Shortly before his death in 1857 he endowed the Royal Irish Academy with a fund for the publication of its *Irish Dictionary* and he also left the Academy Library a valuable collection of books.

From 1840 to 1858 Hermitage was the home of Richard Moore, Attorney General, and in 1859 it came into the possession of Major Richard Doyne. From 1872 to 1885 it

was occupied by George Campbell, merchant of No. 58 Sackville Street, (O'Connell Street) and after lying vacant for a few years it was tenanted by Major Philip Doyne of the 4th Dragoon Guards. In the 1891 census Colonel Frederick le Mesurier, barrister, is returned as occupier and in 1899 it was William Woodburn.

BUSHY PARK AND SHAW'S WOOD

Bushy Park House, accessible via Templeogue Road and no longer part of the grounds of Bushy Park (or Shaw's Wood as it was known as for many years), is now surrounded by a recent development of red-bricked townhouses and apartments. It was originally owned by Arthur Bushe of Dangan, County Kilkenny, secretary to the Revenue Commissioners, who built the house in 1700. The house, at this time, was known as 'Bushes House', on a site of 4 hectares. A John Hobson became the owner in 1772 and changed the name of the house to Bushy Park, possibly after the park in London of that name.

Bushy Park House was then purchased by Abraham Wilkinson in 1791 who added almost 40 hectares to the estate. The house and estate were given as a dowry to his only child Maria when she married Sir Robert Shaw (1774–1849), 1st Baronet, Member of Parliament and Lord Mayor of Dublin (1815–1816) in 1796. The Shaw family of Bushy Park House, was a very important and prominent family in Dublin's financial and civic life. Bushy Park Estate was the family home from 1796 until its sale to Dublin Corporation in 1953. The estate included lands in Terenure, Kimmage, Crumlin, Roundtown, Dublin City and the parish of Rathfarnham, which, unlike today, were mostly farmlands in the nineteenth century. The estate lands were managed effectively and parts were leased to tenants to generate income, which, in turn, was used to maintain the family house.

Bushy Park House became the seat of Sir Robert Shaw when he left nearby Terenure House. The house itself is a three-storey overbasement Georgian house with a plain façade. In the early part of the nineteenth century the front of the house and the northern wing were rebuilt, with large ground floor windows and external shutters added. On the south side of the house were large enclosed gardens, and on the north side almost one hundred acres of parkland, extending as far as Terenure village. A long avenue led to the Rathfarnham Road while the original short avenue led to what is now Fortfield Road/Templeogue Road.

The Shaw Family
Te ipsum nosce: 'Know thyself'

Shaw family motto

The Shaw family moved to Dublin in the eighteenth century. Robert Shaw (Senior) prospered as a merchant and became Accountant General of the Post Office. His son, Robert Shaw, became a well-known figure in nineteenth-century Dublin. He became a member of the Guild of Merchants at the age of 21 and was elected as their representative to the Dublin City Assembly (forerunner of the present-day City Council). He was one of Dublin's foremost financial experts, with his own bank, Robert Shaw & Son, at Foster Place, College Green. He was a Member of Parliament for New Ross and Dublin from 1804 to 1826 and, in deference to his position, he was conferred with a baronetcy on 17 August 1821, during King

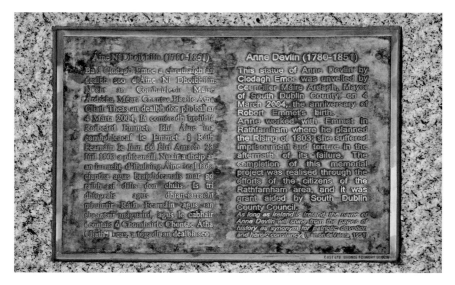

Plaque to Anne Devlin, Rathfarnham village. (Courtesy of Kieran Swords/South Dublin Libraries)

George IV's visit to Dublin. He played a prominent role in the creation of the Royal Bank of Ireland, was an active guild member and was elected Lord Mayor of Dublin in 1815.

In 1796, at the age of 22, Sir Robert married Maria, daughter and heiress of the neighbouring family, the Wilkinsons. His bride brought a substantial dowry and the 110-acre estate of Bushy Park to the marriage. In 1806, Sir Robert sold his family home, Terenure House, and Bushy Park House became the family home and seat for the Shaw family. On his death in 1848 Sir Robert was succeeded by his son, Lieutenant Colonel Robert Shaw. His son, Frederick Shaw, was Tory MP for Dublin City and University of Dublin from 1830 to 1848, and Recorder of Dublin from 1828 until his death in 1876.

GEORGE BERNARD SHAW AND MY FAIR LADY

The estate deeds from the Shaw collection provide a useful insight into landlord and tenant life, showing the extent of the Bushy Park estate and some of the families who resided there.

The deeds give details of lands to be leased and give context to their position by describing the boundary lands and occupants. Like most leases, they specify the terms and conditions of the tenancy, which include some unusual requests such as in a lease between Robert Shaw and Michael Murphy, where Robert Shaw 'reserved the right to hunt, hawk, fish, and fowl on said premises at fit and proper seasons of the year'.

In addition, many of the deeds contain maps drawn to scale, showing the outline and size of the lands to be leased.

One deed in particular from this section stands out: a copy deed of release, where Sir Robert was released from his duties as executor to the will of Lidia Wilkinson. In her will Lidia left legacies to Eliza Doolittle and Isabella Doolittle of Cork and Henry Doolittle of Dublin City.

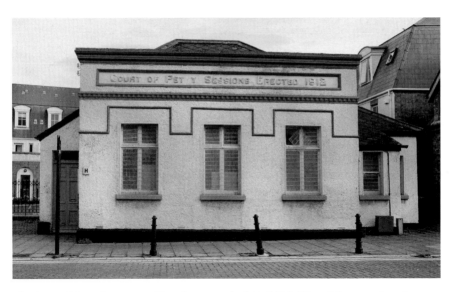

The Court of Petty Sessions on Main Street was built in 1912. The public entered on the left, the judge on the right. It operated as a District Court until 1977. (Courtesy of Kieron Swords/South Dublin Libraries)

The name Eliza Doolittle has subsequently been made famous as a flower girl in George Bernard Shaw's famous play *Pygmalion* (later adapted for screen in 1964 as *My Fair Lady*). It is hard to surmise how G.B. Shaw was aware of the name Eliza Doolittle, her connection was obviously with the Wilkinson family who were related to Sir Robert by marriage. We can only suppose that G.B. Shaw came across her name in such deeds or family letters, drawing inspiration from his family papers to aid his literary creations.

THE DUCK POND AND THE BANDSTAND

The Shaw family was connected with Bushy Park until they sold the house and grounds to Dublin Corporation (Dublin City Council) in 1953. The house and 8 hectares of the grounds were then sold by the Corporation to the Congregation of Religious Christian Education in 1955. Dublin City Council re-acquired a number of acres of woodland and open space in 1992.

The park is noted for its woodland walks, containing mixed broad-leaf trees, the wildflower meadow, the ornamental duck pond, the bandstand with the natural sloping grass-covered amphitheatre and the beautiful Dodder Walk. The Duck Pond is a particularly attractive amenity. It has an island in the centre that is an important nesting site for ducks and swans. The island itself supports planted trees and shrubs, including weeping willows. Birds are the most obvious feature of interest in the pond. The area has a regular breeding population of wildfowl present throughout the year. Species include the mute swan, mallard, tufted duck, moorhen, coot, little grebe and the kingfisher. Interestingly, and despite a long tradition with young children, bread is very bad for ducks! Seemingly, bread has very little nutritional value and can lead to a variety of health problems for the ducks. Humans take note!

The park also caters for football, tennis, boules, skateboarding, and has a fine children's playground, and much else.

RATHFARNHAM CASTLE PARK

Opened in recent years in the grounds of Rathfarnham Castle, this park, in combination with the castle, has been restored by the Dublin City Council to some semblance of its former glory. The parkland, which compromises the wooded area known as Loyola Park, the open spaces in the area and some of the former lands of Rathfarnham Castle, has been restored into one attractive park and recreation area. It includes a pathway system, extensive woodland and the old lake in the centre of the wood. Further additions included a large children's playground, walks, woodland with a smaller playground, ponds and a winding river with an ornate bridge. In the summer of 2013 an ornate section of the park facing the Rathfarnham Credit Union, opened. In the centre is a small pond with a sculpture of three children dancing.

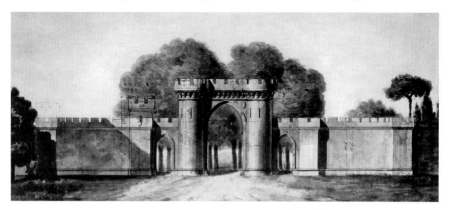

Drawing of the old entrance to Rathfarnmham Castle. (Courtesy of South Dublin County Libraries/Jesuit Archives/OPW)

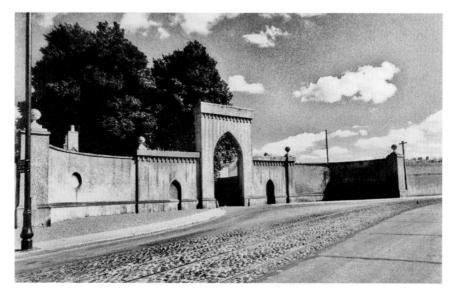

A striking image of the old entrance gates to Rathfarnham Castle. Some of the curved entrance still stands on corner of Castleside Drive. Note the tram track through the cobblestones. (Courtesy of Fr Browne S.J./South Dublin Libraries/OPW/Jesuit Archives)

9

RATHFARNHAM TIMELINE

1199 The confiscated lands of Rathfarnham were granted to the Norman, Milo le Bret. This marks the beginning of the written history of Rathfarnham. Before this time a *rath* or fort existed at Rathfarnham.

1244 Firhouse Weir was built in order to ensure a constant supply of water to the city of Dublin.

1381 The first record of a bridge being built across the River Dodder at Rathfarnham.

1583 Adam Loftus, Protestant Archbishop of Dublin, is granted Rathfarnham and plans to build on the site of the old castle.

1590 Rathfarnham Castle was constructed as a fortified house.

1600 Rathfarnham Castle had to withstand an attack by the Wicklow clans.

1641 Rathfarnham Castle was able to hold out against the Irish Confederate army when the surrounding country was overrun.

1649 A few days before the Battle of Rathmines, the castle, which was garrisoned by the Parliamentary (Cromwellian) forces, was stormed and taken by the Royalists but they evacuated it when Ormonde (leader of the Irish forces) withdrew with his army to Kilkenny, headquarters of the Confederates.

1652 The bridge at Rathfarnham was described by Boate in his *Natural History* as a wooden bridge which, 'though it be high and strong nevertheless hath several times been quite broke and carried away through the violence of sudden floods'.

1719 The earliest reference to a paper mill here was in this year, when a petition for financial aid was presented by William Lake of Rathfarnham.

1723 Wharton's sold Rathfarnham Castle and its lands to the William Connolly, speaker of the Irish House of Commons (and owner of Castletown House) for £62,000.

1725 The mansion which now forms the centrepiece of the Loreto Abbey group of buildings was built around this time by Mr William Palliser.

1742 The Bottle Tower or Hall's Barn was built by Major Hall in imitation of the better constructed Wonderful Barn erected about the same period near Leixlip.

1751 Paper was made at Rathfarnham by William and Thomas Slater.

1765 The present structure of a single-arch stone bridge was erected over the River Dodder.

1769 Until 1783, Henry Loftus, Earl of Ely, was responsible for the classical work at the castle itself and for the erection of the new gate (Ely's Arch) on the banks of the Dodder.

1795 A new Protestant church was erected in Rathfarnham Village to replace the medieval one which had become too small.

1795 Rathfarnham House (Loreto Abbey) was purchased by George Grierson, the Kings Printer, who resided here for a few years.

1798 Rathfarnham was the scene of a skirmish at the outbreak of the 1798 Rebellion. The United Irishmen insurgents of the south county assembled at the Ponds on 24 May under the leadership of David Keely, James Byrne, Edward Keogh and Edward Ledwich.

1803 In order to avoid being arrested before the rising took place, Emmet rented Butterfield House (or possibly one of the other older houses on Butterfield Avenue) in April under the name of Robert Ellis and lived here with Dowdall, Hamilton and others.

1821 Rathfarnham House was purchased by Archbishop Murray of Dublin for the newly founded Loreto Order.

1852 Rathfarnham Castle was bought by the Lord Chancellor, Francis Blackbourne.

1878 The Catholic Church of the Annunciation was erected to replace the old chapel which stood in Willbrook Road.

1908 St Enda's College was founded by Patrick Pearse and was at first housed in Cullenswood House, Ranelagh.

1910 The 1916 Rising Leader leased The Hermitage from Mr Woodburn and moved his college here so that his pupils could have scope for the outdoor life that he felt should play so large a part in the education of youth.

1913 Rathfarnham Castle estate was sold and divided. The eastern part became a golf links. The castle and the south western portion were bought by the Jesuit Order and the north western part was devoted to housing.

1916 On Easter Sunday, Patrick Pearse left St Enda's for the city on his bicycle for the last time.

1930s Fr O'Leary SJ installs a seismometer in a building in the grounds of Rathfarnham Castle.

1935 St Enda's finally closed down.

1953 Rathfarnham Bridge was widened on the west side and renamed Pearse Bridge in honour of the Pearse brothers.

1968 After the death of Miss Pearse, St Enda's passed into the hands of the state and has since been opened as a public park.

1986 The Jesuits sold Rathfarnham Castle.

1999 Loreto Abbey is closed and both the school, which now only takes day students, and the Order's headquarters are transferred to the nearby Beaufort House.

FURTHER READING

Francis E. Ball, *A History of the County Dublin* (1903)

Tony Corcoran/Rathfarnham Parish Liturgy Group, *The Church of the Annunciation, Rathfarnham* (2006)

Peter Costello, *Dublin Churches* (1989)

John D'Alton, The *History of County Dublin* (1838)

Rob Goodbody, *Butterfield House: Home of the Irish Pharmaceutical Union* (1994/5)

Griffiths Valuation (1850)

Patrick Healy, *Rathfarnham Roads* (2002)

Vivien Igoe, *A Literary Guide to Dublin* (1984)

Weston St John Joyce, *The Neighbourhood of Dublin* (1912)

Lewis's Topographical Dictionary (1837)

Local Studies Collection at the County Library, Tallaght; Ballyroan Library; Whitecliff Library

Harry Neligan and John Seymour, *True Irish Ghost Stories* (1914)

Gregory O'Connor, *The Building of the Parochial Church of Rathfarnham* (2008)

Rathfarnham Community website

South County Dublin Local History Our Villages website

John Taylor, *Taylor's map of the environs of Dublin extending 10 to 14 miles from the castle, by actual survey, on a scale of 2 inches to one mile* (Dublin: Phoenix Maps, 1989)

Thom's Directory

If you enjoyed this book, you may also be interested in...

Portobello In Old Photographs
MAURICE CURTIS

In this book, Maurice Curtis, takes the reader on a visual tour of Portobello through the decades, recounting both the familiar and the events and places that have faded over time, revealing many fascinating details, including the fact that Dublin's Portobello was named after an area on the East Coast of Panama! This, and much more, is captured in a timeless volume, which pays fitting tribute to this well-loved part of the city.

978 1 84588 737 7

Rathmines In Old Photographs
MAURICE CURTIS

Rathmines is one of the country's most well-known suburbs, home to heads of government, vast swathes of students and local families alike. In his latest book, writer and historian Maurice Curtis takes the reader on a visual tour of Rathmines through the decades, recounting both the familiar and the forgotten, those features and events that may have faded over time. Illustrated with over 150 archive photographs, this fascinating book pays fitting tribute to the place Rathmines has carved in the history of all who have passed through it.

978 1 84588 704 9

The Liberties
MAURICE CURTIS

Following the murder of Thomas á Becket, King Henry II decreed that an abbey be founded close to the present-day St Catherine's church, Thomas Street, Dublin, in Becket's memory, and the monks that founded it were to be free from city taxes and rates. This 'Liberty' expanded and took in the part of Dublin which today is known as the Liberties, one of Dublin's oldest and most interesting parts of the capital. In this book, author Maurice Curtis explores this fascinating history and its significance to the people of Dublin.

978 1 84588 771 1

Visit our websites and discover thousands of other History Press books.

www.thehistorypress.ie www.thehistorypress.co.uk